Among the Boat People
A Memoir of Vietnam

Nhi Manh Chung

Unbearable Books from Autonomedia
Series Editors: Jim Feast and Ron Kolm

Among the Boat People
A Memoir of Vietnam

Nhi Manh Chung

Autonomedia

Acknowledgements

Versions of the first few chapters were published
in other places, but over the last twenty years,
each was extended and rewritten.

An earlier version of "Among the Boat People"
was published in the *New York Press*, December 23–29, 1992.
An earlier version of "The Pool at Sai Woi Club"
was published in the *New York Press*, March 31–April 8, 1993.
An earlier version of "Soeur et Monde"
was published in the *New York Press*, June 29, 1994.
An earlier version of "My Father's Last Concubine"
was published in the anthology *The Unbearables Big Book of Sex*
(Brooklyn: Autonomedia, 2011)
An earlier version of "Mei Gwok,"
with a different title was published in *From Somewhere to Nowhere*
(Brooklyn: Autonomedia, 2017)
An earlier version of "One Day (June 28, 2011)"
was published in the anthology *What I Did Today*
(Kingston, NY: Chapbookspublisher.com, 2011)

Autonomedia
POB 568 Brooklyn, NY 11211-0568
info@autonomedia.org
www.autonomedia.org

Contents

Photo section follows page 96

For

my mother, Lieu
柳
1918–1978

my brother, Kwok Chieu
国超
1948–1978

my sister, Bao
宝
1960–1978

Forever in my heart
永远在我心裡

This Book's History

In 1992, I entered a contest run by *New York Press* and won first prize for a piece I wrote about being one of the boat people. The gracious editor of the paper, John Strausbaugh, encouraged me to write more about growing up in Vietnam, and the *Press* published two more of my pieces. I guess I was naïve, but I thought I might find a larger audience, and so I wrote up more of my experiences, turning them into a book, which covered everything included here (except for the seven-page "One Day") up to the last chapter, that is, more than three fourths of the contents. Sending out the book to publishers and magazines, and relying on Straubaugh's positive thoughts, I had high hopes and stars in my eyes.

Twenty years passed.

So, things did not go as planned. The *New York Press* was bought by a new publisher and Strausbaugh, perhaps the last great editor of the New York alternative press, was summarily fired. I found that editors had little interest in my work, in fact, from the rejections I learned my work was "too scattered," "inconsistent," "totally lacking in feeling," and so on. I accepted I was not a writer, but, because of two people, I kept doggedly sending the book out. One goes without saying; the other is the poet and fine artist, my friend Yuko Otomo. Not only did she love my work, she kept telling me something like: "When wars are over people only want to know who won, what exciting battles took place, and all that military idiocy. People never know what the innocent victims have to say. And that's what your book gives voice to."

Yuko's hope kept me alive, making me think of myself not so much as a writer, but as a contributor to historical understanding. Still, I admit, after the first 15 years, I began sending out the book less often, only to publishers who seemed sympathetic to this kind of work. Maybe, here I was deluding myself again.

However, in the last couple of years with new prompts, I revised the book and added a final chapter, one I could not have written before I made a return trip to Vietnam. I tried again to find a publisher.

I think I was particularly invigorated by having new free time after retiring from being a New York City public school bilingual teacher, a job I had held for 29 years. However, there were also three people who returned my thoughts to the past.

One was old friend, master photographer, artist, and a premier chronicler of the Lower East Side, Clayton Patterson. He hosts a very open-ended, Internet show on the 8Ball radio network, which he invited me on to discuss my life's journey. It went on for hours and, prodded by his insightful, thoughtful questions, I began remembering things that had long slipped my mind about my childhood and adolescence. Following that encounter, Paul De Rienzo, an acclaimed writer on nuclear power's hidden, seamy history, political analyst and WBAI radio host, invited me on his community channel cable TV show to talk more about my now refreshed memories. Third, Jim Fleming, generous publisher and book designer, perhaps the last great publisher of the New York alternative press, agreed to put my book in his Unbearables series, reaching out to me with a helping hand where, in the past, every publisher I approached, slapped my hand away.

And through it all, it goes without saying, was my husband, with whom we raised our kids, weathered some hard knocks and were faithful to our life-long pledge of love.

All these people kept my book dream alive.

Chapter 1
Among the Boat People

To sleep, to take a risk.

So I used to think in those days, in 1978.

There was only one stairway leading up from the hold of the boat where I was sleeping. The space was huge, spreading out beyond my bed as if I were a mite in a giant shoebox floating on the waves. It contained about 2,000 people, refugees. We lay on big sacks of beans, except for a few people who had cadged straw ticking.

If the boat capsized or became flooded, most everyone would drown trying to get up the stairs.

Our ship was anchored about one mile out from Manila. There had already been one typhoon as we waited in that ship. Before the storm, we were transferred from the freighter to a Philippine naval cruiser. That had kept us safe. But I wondered whether another storm might appear out of nowhere and swamp us before we could get help.

Nowadays, Cantonese friends have called me "pa say," that is, "afraid to die." Not complementary and not to be taken literally. It means worrying too much about little things. I confess I am guilty of that, but my worries are not that deep. Not now. Back on the ship, my fear of drowning was wrenching and arresting.

It seemed like every night I dreamed of drowning, then woke up, then drowsed off. My sleep was a chain of nightmares.

Also I worried about my persistent cough. Right now, we refugees had been applying to be accepted for admittance to any country that would have us. Some went to France, others to Canada, Denmark, Greece, Egypt or the U.S.

France only wanted families, while Canada was taking single people. Once you were tentatively accepted, you were taken from the ship and placed in a camp on shore. You had to undergo a medical inspection to see if you were fit. If, for example, a person was found to

have lung disease, the individual was kept in the camp till it was cured, up to two or three years, or until he or she died.

I was being processed to go to Canada, though it wasn't my first choice. I had written to my stepbrother, the child of my father's second wife — in Vietnam polygamy was legal. And at that time, there were few men around because so many died in the war or came back crippled. They lost one arm, two arms, one leg. After the war, I saw many people begging on the street and they had no two legs. No eyes or one eye. All kinds of terrible scenes you can see on the street. But not anymore. I heard that they want tourists to come to Vietnam, so they put all those people in one city. They keep them all there. They are not allowed to come out. So no one can see these people.

So in those days there are so many women, so one man can get as many women as he wants. My father has a concubine. This woman moved into my house, married my father. She has a son with my father that I call stepbrother. But I have never seen him before, but I heard about him. He is very intelligent. My mother said that that brother is very smart, very intelligent. So she gave me his address in New York.

From the boat, I tried to contact my stepbrother, who lived in New York City. His family had moved to America before I was born. I assumed he never knew about me. Before we left Saigon, my mother said, "Look, this is your stepbrother's address in New York. Memorize it. You don't want to bring anything on your body because they take everything. Memorize the address and the name. And when you go out, contact him and ask him to sponsor you." And my uncle said, "When you get out, go as far as you can. Don't stay in Hong Kong; don't stay in Asia, because pretty soon the Communists will take over all of Asia. The farther, the better. The Europe. Far, far away from Asia."

So I got the address from my mother, I memorized it. When I got to Manila, I wrote, saying, "I'm your stepsister. I know you haven't seen me. I haven't seen you. But I got your address. I'm here, I escaped; I lost my family. I would like to go to America. Would you please sponsor me, but if you don't sponsor me, it's okay. I'm not going to get angry because we have never seen each other. So if you sponsor me, I'm happy but if you don't sponsor me, it's okay. I will just go to another country. But I would like to go to the place where I have somebody I know, someone that I am blood connected with." Then I never got a letter back for three months, so I think that he doesn't want me. So, I had to decide where to go.

I had been approached by Denmark. I heard it was a very rich country. When Denmark accepted you, they sent people to measure your size to give you big, thick clothes for winter over there. But then someone told me that when a man goes out in the street in Denmark, he would be approached by a woman for free sex. I was thinking that if I lived there, my husband would not be faithful because he could get free sex.

I had heard Canada wanted 500 single young people. I was 24. I registered and was accepted right away. I was waiting patiently to be processed into the camp in Manila, hoping my cough would go away.

I guess I should have left Vietnam earlier. Right when the war finished, many left, but those who could go, able to get on warships and planes, were those who had family members who worked for a U.S. government department. Those people can go to the airport, but outsiders are not allowed to go to the airport.

Still, one friend, Bing, told me I could leave at that time on a big ship that was in Saigon harbor. But my mom told me "No. We stay together. We live; we live together; we die, we die as a family." That's why I didn't go. Bing didn't leave then, but later snuck out to Australia.

However, after our father died and we lost the factory which supported our family, as I will explain in detail later, we needed money to survive. My brothers, except for one who was disabled, had left the country, so we had to depend on my sister's husband.

My sister's husband Nhuan was a very strong man, about 40 years old. After the war, he couldn't find any work. And, if, during the war you didn't join the Communists, which he didn't, now you were considered "no good." So, before he died, my father told my sister's husband, "Why don't you go to the countryside?" What they call "the jungle." "Go and live there."

At that time, the area we call "the wilderness" was open and you could take land to farm. He went there because in the city there were no jobs. So he carried some money and he went there and lived there. He had to dig a well and plant crops and build a house. There's nothing there. There are wild animals.

It was not a good situation. You ask someone to go from the city and live in the country. It doesn't work. If you asked me to hold a hoe to dig the soil, I can't because I never did that before. My hands are soft. I'm only holding a pen or a book to study or do accounts. How can people like us survive in the wilderness?

Nhuan took all the kids with him, three or four, and the maid to

help him settle down. My sister was sick at that time so she stayed home in Cholon till things were set up, but they never did get set up. Nhuan died of poisoning from something he ate or drank.

At that time, the government controlled everything, even the medicine and the hospitals, meaning, you cannot get a doctor easily unless you are working for the Communists, only then could you get seen in a clinic or a hospital. But otherwise, you are like trash; you are nothing. The government seemed to say, "If you die, that's your business; nothing to do with us."

So when my sister's husband died, they all came back to the city and my mother now had to take care of the children. By this time, our father had died also. As a family, we were starving and didn't see any way to stay alive.

Before the Communists took over, our uncle, Tho Hoai, owned a jewelry store, like the kind on Canal Street in New York. He was very rich and lived in a five-story building. Even though, the government seized all businesses, he still had some concealed wealth.

When he learned of our plight, he told us he was going to arrange for my mom, my brother, my sister and me to leave the country secretly. One evening, we went up to his bedroom where he had a secret door, very small. He crawled through and brought out a bowl full of gold rings. He said, "Pick one to fit your finger, cause when you go out on the boat, you need to have something of value. Once you leave Vietnam, the money is useless. So each of you get one golden necklace and one ring." Each person took a ring and necklace. These rings were real gold, not the 18- or 24-karat ones but real. You press it hard and it curves. He also gave each person one 100 dollar bill, U.S. dollar. The necklace we have to wear and we put on the ring. And then we have three sets of clothing to bring with us and some sugar and that's all. And can you guess where we hide the $100 bill? We put that money in a plastic bag and stuck it in our anus.

I heard that some people that came out wore very thick shoes. They had a hole in them, so they put gold or money inside. And some refugees cut their clothing at the seam and hid money in the lining. They try everything.

Uncle Hoai was helping all his relatives escape. Most of them made it through. Only ours was not lucky.

The first time we tried to escape, which my uncle arranged, my cousin, he and his pregnant wife, went first. They got caught in the

mountains. They stayed in a small hut for a few days and were found by the Vietnamese soldiers and arrested. Because the wife was three or four months pregnant, they let her go after a few days. But my cousin, he was a young man, was in jail for one year. I heard he was kept in a room with so many young men that had tried to escape. They eat there, they go to the bathroom there, everything in one place. When he came out, he had skin problems because it was so dirty in the room.

When my cousins were arrested, we were on our way to go up and meet them, but then we heard he was caught, we turned around back to the city. That was the first time we tried.

On the night we left, people came on a bus in the middle of the night. We snuck out of the house. It was very late. There were no cars. This was in Thu Duc, which is like one hour driving from the city. It was the country, trees. I live in Cholon, which is next to Saigon. It's like Brooklyn and Manhattan. So from Cholon, the bus took us to some place about one hour to where there's water and the boat right there waiting, parked at a quiet dock The boat was as big as a house with three levels. It was so dark when we went in. We all sat next to each other, very tight, because there were so many people. The owner had all his relatives along, more than 30 people. They were in the lowest level. I heard later that they all died because they were stuck inside and once the boat was capsized, the water got in and then they couldn't get out.

I told you I had a cold. I got that cold when I was dumped in the water. The captain who had been contracted to secretly take refugees from Vietnam to Indonesia was too greedy for gold. To get on board you had to pay 12 pieces of gold. The boat was overloaded with 600 passengers. All the ingots were put into the bottom of the vessel. Within an hour of sneaking off the coast, we began to founder. The ship sank and we all ended up in the water. Another ship was close by and a few of us managed to get pulled onto that ship. 200 survived. Some families lost everyone. Young, old, anything.

I'm one like that. Only one left. Some people got crazy when that happened. Can't sleep, can't eat, become crazy.

My uncle arranged four families to come out. One family is a single man, a middle-aged man, by himself. He was drowned. The other family is two daughters and the parents. When we were waiting to leave the place to go to the ship, they were always chanting with the beads. "Namo, Namo, Namo," always chanting, very devoted, religious people. They all drowned. Me, my mother, my sister, my brother, I'm

the only survivor. When my uncle heard that there was only one daughter who survived in my family, he thought it was my sister, because she was 18 years old, young, and kind of big and strong. And I was thin and looked weak, so they thought I drowned. But when they saw me, they knew that I am the survivor.

The fourth person my uncle paid for was a woman I call Ho Jie. ("Jie" means sister in Cantonese.) She's ten years older than me. She came out with me together. It's funny. Ho is a very quiet person. She had never gone to the beach or pool in her life in Vietnam because she didn't know how to swim. Later, I asked her, "How did you get up?" My sister knows how to swim, but she was drowned. So I said, "How did you survive?'

And she said, "Oh, I don't know. I dropped into the water and then like I floated up." And when she surfaced, she said, "I saw a life preserver and I just hold that." And then she was saved.

My family had four people. My mother and older brother couldn't swim so when we went down, I knew they were lost. However, my younger sister was a strong swimmer. She didn't make it either.

Later, on the boat where we were living in Manila Bay, I met a Vietnamese woman who was something of a celebrity. She was on a small boat, one with about 30 people. It sank and everyone but her died. One person. For ten days, she floated on a piece of wood, eating seagulls and drinking rain water. She was 16 years old. They put her on TV and we all talked to her. Everyone wanted to get her to their country.

If you think about it, things happen so fast. Only one night, everything changed. One night you don't have any friends left. You sit with a lot of friends and relatives. In a few seconds, everybody is gone. Then all the faces you see are strangers. All soaked with water, sitting there, crying.

And no belongings either. All the belongings sunk in the water. All you have left is the gold ring on your finger. Everybody was wearing some gold. That's the only money you can bring out. Everybody was allowed three pieces of clothes, one gold ring and one gold chain. Before we got on the boat, they checked it.

As I said, the boat was overloaded and capsized. Everything fell into the water. It was so dark. There was supposed to be some light but after the boat was capsized, the lights went off. I remember so clearly, There was suddenly no light and everybody was screaming. Everything was shaking back and forth like the Titanic, and then suddenly one side went up, and once it shifted, everything slid to one side. Then

I heard people screaming, in Vietnamese and Chinese, and some are chanting, calling on Buddha or Christian or whatever. I heard the people chanting, in Chinese and Vietnamese, "Buddha, help me."

At that time it was totally dark, 100 percent darkness, and you don't see any light anymore. Nobody knows what's going on. I was sitting with my mother, my sister, my brother. But before you die, you try to struggle to survive. I was grabbing for some metal bar above me, because when the boat was beginning to go down, I could feel the water coming up to my legs, this cold water, and this also lifts me up higher, so I was grabbing this bar, I didn't see but I was holding it. And I feel a lot of people holding my legs, struggling to survive. I don't know who was that. So I started to kick, kick, kick. All those people fell down to the water before me.

Months after it happened, I kept dreaming of it. It's really a terrible thing to be swimming in a heavy sea at night, choking on dirty water, with people screaming all around you, screaming like hungry ghosts coming out of hell, all around you and below you.

When people pulled my leg, I kicked them down. Later, I thought, maybe that was my mother. I didn't want to think about it.

After a few moments, I let go, because I know how to swim. I'm a pretty good swimmer. Of course, not very good, but pretty good. If you throw me in the water in the deep sea, I can survive. I just let my hands go and I was floating in the water,

I was swimming a little bit and it was so dark you couldn't see anything. Very soon there is another boat that came behind, which saved some of us. I heard the old people and the children all drowned. The ones who were saved were young people like us, 20-something or 30 years old. Things happen so fast.

(It's funny how things come out. In January of 2017, my uncle Hoai, the one who paid for everyone to come out, passed away, 94 years old. We had a funeral for him in California and then I talked to some of the cousins, who left after me. Many of my cousins were there, because we all came out because of him, because of my uncle. And while I was there, one cousin told me, "My mom took me to identify the bodies, the bodies of your mom and sister, because they floated back to Vietnam's shore." But they couldn't find my brother's body. It disappeared. The cousin went on, "I saw your mom's body all purple color. But your sister is all red. Her skin is so pretty, she looked like a live person." I said, "I didn't know that." He said my sister's head had a

cut. Maybe she hit something and she got unconscious. My sister's head had a big, deep cut right on the forehead. But Ho Jie survived. I don't understand. Chinese talk about "ming won." Fate.

How things come out. It was 39 years since I left and I was just learning this. After we left the country, we didn't have that much contact with our cousins. That's why I never heard this about Bao, my younger sister who was drowned. They live in Boston and I live in New York. We seldom see each other. Everybody's busy with their job.)

After swimming a little, I was taken aboard a big ship called the Panama. The Panama can hold 2,000 refugees. And I went up there. I can still remember that the ship had three levels. The top level was open but they were making some piece of canvas to block the sun. I was in the middle level. We were on sacks of green beans or red beans, lying on top of those. I think they had put those to hold the ship stable. When we got to the ship, there were so many people there already, so many refugees, so many trying to get out of the country. We were allowed to go in and sleep in the corner: Each body right next to each other. At night, I don't know what's going on. "What's this so itchy?" I said. I don't know what they were, these little tiny things that crawled out from these green beans. We were bit by them and also everybody was coughing because everybody stayed in the same space.

People later asked me how I dealt with the trauma. One woman cried all the time. She lost more family than I did. Her husband, son, parents and husband's parents all drowned. But I didn't cry that much. I had made friends on the boat, people who were a similar age, in their twenties, who slept around me. They also lost their family but nobody lost like me. Tiem, my classmate, lost her parents but still had a sister. Another man had lost his wife. Another man lost his children.

We spent all our time together. We slept next to each other, talked and would go up on deck together where we could watch the waves and the seagulls flying.

I guess when big things happen you either get crazy and kill yourself or become strong. The Cantonese put it like this, "Jurng bey oi been sing lick lern." (Move your sadness into strength.)

To return to my story, one morning after I opened my eyes, I found a lot of people moving around. The electric lights had been switched on, so it was already 5:30 or 6 am. At 8, we would get breakfast. Our team leaders would go up on deck to get closed pots of congee ("jook"). We each got five spoonfuls.

For the first month, that had been our only food for the day. That was our time at sea, traveling from port to port, looking for a harbor. We first got to Indonesia, but they wouldn't let us land. In every country, we were either towed back out to sea or approached by a fire boat, which sprayed us with water until we backed away. They said they were afraid to let us disembark because we might have Communists concealed on our ship.

In Indonesia, they did give us some congee. They give us the food to take to the ship and distribute, but they don't want us. They say, "You guys may be Communists. We don't know who you are." It's something like what happens today to refugees from the Middle East. "You guys could be terrorists," people say.

I think I understand refugees today because you don't want to leave your country till it is necessary. Who wants to leave their own country? You were born there; you were raised up in this environment; you get used to it.

Finally, we were allowed to anchor off Manila and transfer to a bigger vessel, but they don't want us to get on shore because they don't know if we are Communists. They let us park, miles away from the shore. At night we can see the lights on the street, I guess from the cars, a very beautiful view, but we are not allowed to go to the shore. We must stay on the boat. A good thing was that when we reached Manila, we were given a second meal besides the congee: a piece of bread for lunch.

I remember the first meal we made off that bread. We were given moldy buns, three or four days old. People complained about the taste and smell, but they ate them anyway. Then we all got diarrhea.

That afternoon, it was embarrassing to see the people lined up in two aisles on the listing ship, waiting to use the toilets, which were simply a portion of the deck closed off with semi-opaque plastic, open on the outside. Once inside, you squatted, pushed your butt between the railings. Having to crouch under that clammy plastic was uncomfortable, but I stood in line with the rest. I was thinking that when I eliminated the bad food from my stomach I would also be eliminating the good jook I had eaten earlier today. And I worried about the men seeing my body profile through leaden-colored draperies. Queasily pushing greasy hair from my eyes, I watched the sea birds slung out against the deeply acquaed sky.

This morning of which I was speaking, waking in all the hubbub, my stomach was as tightly balled as a little kitten. I wiped my face with a snot rag. Shaking my head, I began to make my way past the mal-

nourished children and their bedeviled, emaciated mothers.

Starvation is a kind of passion. Like love, it discolors what is visible. My mouth always had a leathery taste, sometimes salty; so that everything I ate was acrid, flavored more by my own juices than by the food's original taste. I found eating stirred entirely new feelings in me. What I ate had no taste, no savor, but it limited the pain in my belly. Eating had a different purpose for me then. Life.

I went upstairs that morning to get a place on the rail. This was a favorite hour of mine, just past dawn, with the sun right on the water's horizon, its rays egg-yellowishly in color, throwing into the upper sky all kinds of purples and grays.

I also liked the rail at night. Not at sunset but later when the sky was fudge colored, not yet pitch black. Then you could see the lights of Manila. In the day, it was too far away but at night the city's lights were as shiny as red buttons on the beach.

In the mornings, my thoughts would be empty. Guided by the rhythmical v's breaking against the prow where I leaned, I grew forgetful. Nothing in mind, hearing only, coming distantly from the ship's bridge, a Chinese opera song as if a theater troupe were passing beyond a hill.

As I walked to the rail that morning I was stopped by one of the Taiwanese sailors that I knew. "Manh Nhi, jaw ten twon jawn jawn lee." (Nhi, the captain was looking for you.)

"Gee ma?" (What for?), I said.

"Nee gaw gaw gee ye fong ceen ga li." (You have a letter from your brother.)

In the letter, he wrote, "I didn't get the letter because I moved, and now I got the letter from the old place. And now I know you want to come to America, I am going to sponsor you."

After I read the letter, I felt a terrible weight descend on me, a weight of possibility and future. And I knew the tremendous joy that comes only once in your life.

I knew, and it was true, when I came to New York City, I would have to fight to survive. I had gone from one big family to nothing, from never worrying about money to always thinking about money. You cannot look back, though, I said to myself. I must enter the new world. In my heart, I said plainly, "This is your life. You can only succeed, you cannot fail."

Chapter 2
The Pool at the Sak Woi Club

1. Saigon, 1967

The wind in a room.

Often, though the club would be a hive of activity, with waiters, sunners, diners by the food counter and children bounding through the wading area, the main indoor pool would be empty. A current of air would undulate along its placid surface, raising a single wavelet that glittered outstandingly like one flounce on a plain dress.

Ringing one side of the pool would be the French women in string bikinis with their shapely legs and (to me) awesome breasts, their bodies creamy with suntan lotion. These Europeans seldom went in the water, so the club was filled with swimsuit-garbed people who never swam. This made the pool like a bay that was empty but surrounded by ships in drydock.

When I was 15 years old, I learned to swim there. I felt gangly and ungainly as I walked along past the row of reclining, full-bodied white women. As a rule, the Sak Woi Club (Club Rocher) was closed to Chinese, but because my father was a manager for the Taiwanese of a large (2,000 worker-strong) textile factory, our family was allowed to be members. If you reach a certain standard, you can join this club. So as a child, I was able to join and learn to swim there.

Everybody who went in the pool had to take a shower first. And there's a woman with a mean face, and she's watching you to make sure you take a shower. You don't take a shower and she says, "Go back and take a shower." So the water is very clean and plus there's not so many people in that pool.

When the the French women swam, though their eyes and facial structure were concealed by goggles and cap, as they rose from the water, when doing the frog stroke, the delicate strings of their slim

necks and shoulders were visible. I loved to see their sturdy flanks and muscular arms draped in water so transparent that they seemed to be swimming in a glass of white wine.

2. Thu-Duc, 1976

The Chinese in the city had a saying, "Man doe gung chan dong mai jow you jow fai de." ("When we smell the Communist wind, we have to run very fast.") The saying indicated the dread we felt when we knew they were going to take over the country. The Vietnamese had no great love for the Chinese, and we knew we would bear a large brunt of the burden in supporting the country's reconstruction. What exactly this would cost us was unclear. We Saigonese Chinese waited like sheep who knew we would be sheared but not whether we would be slaughtered soon afterward.

Now, if there was one thing the Communists were expert at, even better than at dialectics, it was at squeezing money.

Once the Communists came to power, the most deep-thinking Chinese, like my uncle, preempted intervention by immediately "donating" their goods and factories to the conquerors. Such people were given special consideration by the authorities. In the case of my uncle, well, he was an old man anyway. Those who resisted such donations had their enterprises seized while they ended up imprisoned or dead. But what about those, like my father, who could not give up as much as they were expected to yield? Father quickly, if grumbingly, turned over all of his property; but he could give little more because he didn't have all the wealth, in gold or jewelry, they thought he had. During the boom, he was always expanding our factory, adding sheds, workers' housing and a driveway. He kept returning his profits to the business. True, he was an old man now, too, but the Communists didn't trust him and they were desperate. Like a handful of dusty, bruised grapes, he must go in the press.

The government had three ways to get our money.

They changed the currency first. All old-style dollars had to be turned in. When you surrendered your money, you were registered and got $50 (Vietnamese). If you turned in $10, you got $50. If you turned in $1,000, you got the same $50. You could only buy food with allotment coupons, and unless you were registered, you couldn't get those coupons. What good was the old money anyway? It was worthless on the world market.

So each month you got a ticket, allowing you to buy so much bread, so much rice. I remember when we got the rice my mom spread it out on a piece of white paper. You had sand, you had crusts of rice. You had to pick that out, and when you finished, there's not that much left. So people would try to buy rice under the table.

Second, the government sent people to live in your house. When the Communists came over, you have to hide all your gold and the jewelry if you have any. Ho Jie's mom had a lot of gold and jewelry. My uncle was a very good friend of hers, so he went to her house and snuck out all the gold from her.

At that time they send the little high school kids to live in your house. They stay in your house every day. They stay 24 hours. They have shifts. They want to see what you eat. What kind of food you buy from the market. They would confront the family members with: "You say you have no money. Where you get all this money to buy this food? Where you hide the money?"

The mother may say, "I don't have any money."

They say, "Oh, you have chicken. You have fish. Where you get the money to buy this? How you get the money to spend on this good food?" As I said, every family has only $50 so no one should have been able to buy meat.

They are using high school kids to do this spying for the country.

These are students from junior high, high school, and they don't know anything. They think this is the way to show you are loyal to your country. They don't have any school at that time. They sent those little kids to live with you for months.

They search your house for money and follow you to see where you go.

Third, if they are convinced you have wealth, as they were in my aunt's case, since she owned a jewelry store, they capture you. They say to you, "I want you to come here. We have a few questions to ask you." Then they keep you in a hotel for months. They wake you up anytime and demand that you tell them where your gold is. Almost every person who has a business gets this treatment. My aunt was in prison for many months.

Here is our situation.

Father had one Vietnamese clerk, Hue. All the others were Chinese. She was not as good as the others, but we needed someone who could write Vietnamese. She kept asking for a promotion but never got

one. Once the government seized the factory, she became the union representative. If you do that, you get a good job in the factory.

Father said this woman had betrayed us.

The factory was full of North Vietnamese soldiers. They were afraid we would steal something to sell.

Every morning all the employees had to sit in a circle. Father had to sit in the middle and Hue accused him of things. Things kept getting worse. As I mentioned, I had heard about a secret boat leaving the country and I asked my parents what to do.

My mother said, "How can a young lady survive? You will be cheated by people in America. We are diligent people. Let us all die together."

Father said, "I believe we can work hard to survive."

The rations were sparse. For six people for one month, three kilos rice. And it wasn't good rice, but sa gook my. Rice with sand inside and husks. We cooked it mixed with guy may, that is, yams.

We were starving and mother went crying to uncle, who used to own a jewelry store. He began selling (his hidden) gold on the black market to get us food. This shamed father.

He was also under pressure from the Communists, as I said a moment ago. They put him at the center of the circle. "You oppressed your workers," Hue said. "You hid your gold. You must give it back to the people. Where is your gold?" The other workers joined in the attacks. They said, "All these years you paid us very little and we were overworked. You are sinful." I don't think the employees really knew what to say, but there were Communists there, North Vietnamese, and they told them to pile on my father. In a Communist country, if you have property, you are guilty; if you have money, you are guilty.

During the week, we slept at the factory in Thu-Duc. One cold morning, near the time of French Christmas, I remember a sluice of cold wind that stove through the wooden wall slats. I woke timidly, still flattened out like a tire tread by lack of sleep, vigor and food. I was so hungry, like a slave to hunger. Sometimes I would steal and wolf down raw noodles when the soldiers weren't looking.

That morning I brushed the water along my face. I felt it hitting me like a series of slaps.

The hallway was filled with cats, prowling and meowing. Many hung around the factory and encampment, waiting for droppings of food and hunting down our abundant mice. I bent to chuck my favorite under the chin.

Father's door was hard to open. When I got it open, I saw him in bed, staring at the ceiling, as if entranced by the tar paper. His mouth was open like a flap or like a pouch ready to receive a coin: his skin no longer orangeish but white. Perhaps milk had been spilled all over him. His hand was curved like a chicken foot.

I tried to shut the door, crying, pushing back all those filthy animals. For if a cat crosses a dead man's body, the corpse will rise.

(I told you it's funny how things come out. The night my father died — and it's something I didn't learn till years later from my uncle Hoai — he tried to call to me. I was sleeping and there was a thin metal barrier between our two rooms. When he was having a heart attack, he used his fingernails to scratch the wall to try to call me. But that night there was a thunderstorm, very heavy rain, and I was young, so I slept like a baby. I didn't hear anything till the next morning.

Years later, when I visited Uncle Hoai in Los Angeles, he told me the wall on my father's room had a lot of scratches. Probably he tried to call me, but I didn't hear anything.)

I had to send someone back to the city to call my mother. She had to look for a piece of land, a grave, and hire a monk to come and chant. In Chinese culture, in Asian cultures in general, I think, if a person dies with no one surrounding him (or her), that's not a good sign. So the monk told us to sit around the body. He started to chant, "Now your family members are all surrounding you. Now you can go peacefully."

Right after that, from his eyes, ears and nose, blood came out. And that sign meant that he had heard us. He was communicating, "I know that you guys are surrounding me, so I can go peacefully." I heard about this thing for a long time, but I never saw blood coming from the ears, eyes and nose. He heard what the monk said.

Someone asked me if the Communists still allowed Buddhist monks as the Communists are against religion. I can only say that at that time they ignored the monks because their target is the rich people.

3. Saigon, 1976

I stood looking at a pool that seemed to be filled with Kool Aid. Crowded, sudsy, and lime-colored, the water teemed with the sandy, ruddy, smoky bodies of Vietnamese. Many of the swimmers were veterans: scarred, disfigured, de-limbed, so their swimming was erratic, jarring, off-course, cranky. There were no discernible lanes such as the

Europeans had established, no pathways through which swimmers could move along in orderly queues. Everyone was swimming, paddling, and flopping this way and that, acting as would a mad rush of waterbugs when a stone falls in the pond.

Looking closer, I saw the water appeared greasy, as if it were made up of sheets of wax paper spread in diaphanous layers.

There was no chlorine, no chlorine smell, but an odor of sweat, urine and burnt rubber. I dove in.

I think I was the only Chinese in the club. It was the same Sak Woi Club that had been seized by the government and now opened to party members and factory operatives. Since our factory had been taken over, I had been running a machine and this entitled me to use the pool.

I mentioned already, that the French had kept a woman at the door leading from the showers to the swimming area. She looked as stern as the cow that stands at the Gate of Hell. The lady reproved and turned back anyone who had not showered. Now that woman was gone and people walked in off the street, trunks under clothes, stripped at waterside and jumped in. Since not many people had running water at home in those days, I think, some used the pool for bathing not for recreation.

I broke the surface angry. Some flailing swimmer had lashed me along the leg, making my flesh sting as if it had been cut by a sapling. I had a gagging taste in my mouth.

Usually when you're in the pool, you swim from this side to that side and then back to this side in a line. But these people swam in all kinds of directions. I could not swim because they hit you everywhere. They may not do it intentionally, but you feel people's hands on your body.

I jogged my eyes open, swam one length, then removed myself from the messy pool.

Admittedly, there was equality. It was not the French and the Americans taking everything. Now no one had anything.

I moved forward, shouldering aside a tracery of wind that swept my dirty, drizzling locks.

Chapter 3
Soeur et Monde

1. Albany, December 1992

Feckless day.

The crust on the snow surrounding Arbor Hill, a low-lying housing project, was shiny and immaculate. Aside from a slight trigger of wind that occasionally shushed by, the area was soundless. No one was stirring. As we unpacked the Christmas presents from the car and walked from the parking lot into the project's courtyard, we didn't talk. It was as if the long-anticipated conversation I was about to have would take place under a heavy vault.

I rapped on the apartment door and, eventually, I heard slippered feet descending the interior staircase. "Hey, everybody, open up," I yelled. "It's cold out here."

The mail flap opened. "Bin gaw wah?" (Who's there?)

It was my older sister. I told her, "Manh Yee-ah." (It's me, Manh Nhi.)

"Gaw gam hoy fan goon." (Everybody went to work.)

"Neigh goon mut yeah? Neigh hai okay. Hoy moon la." (What are you talking about? You're still here. Open the door.)

"Gawn um hoy em hoy." (I can't do that.)

I yelled at her, "Neigh fa sein ging ya?" (What, are you crazy?) The mail slot dropped and slippered feet padded back up the stairs. So our conversation ended.

Since being separated in Vietnam, we hadn't spoken in 14 years.

2. Saigon, 1966–1978

Mother was just irritated when she told Binh, my older sister, to stop interfering with the maid, but I could tell my sister took it in the wrong way when she picked up the dagger. She stabbed the maid in the hand,

the one in which she was holding a stalk of the vegetable she was chopping. The blood gauzed the choy sum. The maid spun and whacked Binh in the face with the side of the cleaver so sister sprawled out on the floor, collapsing onto the piles of rice paper we used for packaging.

"Neigh fa sein ging ya?" (Are you crazy) I shouted, very loud, very disrespecting.

Binh was still holding the knife we used for cutting twine in the shop. She stood back up and went after me. I was younger and quicker — I was 13 and she was 22 — so I could dodge her and I ran up the stairs, shooting up three flights to the roof. She was coming behind.

First thing I saw when I reached the roof was our yellow cat, sitting in a flowerpot and chewing grass. He gave me a blasé look. I ran to the back where I could see below us, the afterscape, a military training camp, monotonously laid out with a set of identical buildings as if one were to furnish one's house with only one type of furniture. I ran to the front where the forescape was Saigon's western market, noisy and tumultuous.

Binh emerged from the stairs, puffing like a hungry tiger. She yelled at me in French, "You made mother hate me. I'm your elder sister. You've got to honor me."

The knife was flung down, contemptuously, rattling like silverware thrown in the sink. Binh stood there steaming.

My younger sister, Bao, padded up from behind and recovered the red blade, then looked quizzically at me.

I nodded my head toward Binh, addressing Bao, "Apparently, putting electricity in her brain wasn't the world's best idea."

<p style="text-align:center">❉ ❉ ❉</p>

When Binh first got crazy, she was in high school and deeply in love with the son of my uncle's maid.

Father told her not to consider this man, but she didn't want to listen. Their arguing ripped through the house like the sound of fighter jets, which we often heard as they rose in formation seeking upper sky.

Binh said father hated her boyfriend because he was low born. Father said what he disliked was the boy's immaturity. Evidence: the guy was 18 years old and his mother still prepared his morning ritual. She used to fill a cup of water for him and put toothpaste on his brush. For father, trifling details like that revealed a lot about a man.

Perhaps more parity exists between the Chinese generations now, but in those days one did not act against parental commands.

Binh stopped arguing but became strange. One day she went to market with mother. It was the morning lull and nobody was around but a few latecomers who pottered among the apple sellers, fish and dessert stands, and an old woman who squatted by charcoal furnaces cooking noodles.

Mom told me she had gone shopping to buy more cellophane bags, the ones we used to wrap up the noodles we sold in the front room of our house. Next to the bag seller was a dealer in scarves, straw hats and other cheap finery. She featured a mass of trinkety jade pieces hanging on red string from a kind of hat rack.

After paying for everything, the two of them took a few steps down the aisle when the scarf saleslady, looking like a crow in her black clothes, told them to come back.

Binh said, "Ignore her, mother."

"Older sister," the woman addressed my mother, "I have to inform you something."

Mother trudged back. "What will you tell me?"

The woman motioned mother forward and, pointing a crooked finger at Binh, said, "Your daughter is a thief." She hawked and spit betel nut juice on the ground.

This was so shameful, mother told me. She looked at Binh and saw a new jade Buddha hanging impudently around her neck.

That's not all. That night she was beaten for stealing. In a few days, something worse happened. She didn't come home from school. Somebody came to see mom and said they had seen Binh near the army base. Mom came running out of the house into the front shop where Bao, uncle and I were waiting on customers. She was holding a long knife. The shoppers, thinking she had gone nuts, fled like pigeons who had heard a shot. Mother followed, also running out of the shop onto the street.

"Mama," I said, startled. I didn't know what to do but give chase. Mama was like a hungry witch, flying down the street, one of her braids loose from its binding, wearing a house dress and bedroom slippers. She ran around to the back, to the SVN camp where, at the front gate, Binh stood chatting with a soldier.

Both mama and I stopped, dumbfounded. Gone was Binh's school uniform and braided hair. Binh now had her hair catted up in a red kerchief and wore a plain wrapper. Her mouth was smeared with red lipstick.

"Binh, come here," mother commanded.

Binh's expression changed from a smirk to a scowl as she turned and walked over.

Mother waved at the soldier, "What are you doing?"

"Mama, not in the street," Binh said, a little red-faced.

"You are making our ancestors ashamed," mother commented bitterly. There was nothing else to say.

Binh held out a parcel. "I went to buy some rice paper."

Mother knocked it out of her hands. "Leave that trash."

I looked at the package torn open on the ground, scattering its cellophane contents like transparent money.

❋ ❋ ❋

It was like one moment she as was normal as a person, the next she was nuts. Mother couldn't follow her every step since she was supervising our retail store. Father couldn't have charge of her because he had to manage our factory. We had to put her in a mental hospital where the staff plugged wiring nodes into her skull and ran electricity through her brain.

She came out but she wasn't cured. She still experienced bouts of madness. Then she stabbed the maid and tried to get me. Father said he couldn't pay any more expenses — he had already mortgaged the factory to cover her sanitarium bills. So we decided to lock her in the first floor maid's room. Father had an molder put an iron gate on it, to keep her imprisoned.

We put meals on a bowl and pushed them through the open space of the iron door. Sometimes Binh refused to eat the meal. Binh said I was poisoning her food, and sometimes she left in on the floor and the mouse came out to eat it. We never had mice before that time. At first, we couldn't allow her to come and take a shower so I put a pot outside the gate so she could pick up water with a ladle and give herself a towel bath to clean her body.

We didn't keep her cooped up continuously. After a couple months, we allowed her to come out and have her freedom. When she came out, she couldn't walk well and I had to support her. In preparation for her release, we had to hide all the knives and scissors. Mother put everything under the stove.

At first Binh would be grateful, repentant and respectful to elders.

That lasted for a while. But as she became stronger, she would go out and cause trouble by fighting and stealing. Perhaps my parents should have taken another course, but they were deathly afraid of Binh's getting arrested for something she might do in the street. If she got in a Vietnamese prison, she would die. So, my parents ended by locking her up again.

✻ ✻ ✻

A doctor told mother that Binh should get married to a strong man. The mixing of her blood through marriage could result in a cure.

At our noodle factory was a robust, honest foreman who wanted to better himself. Father introduced him to Binh, who was quite attractive. She possessed a thick, syrupy beauty, a good figure and shapely face.

They got along, married, and moved into the factory. Soon enough, they had a baby boom. Six kids in six years! They planned it that way. This was the early 1960s and the government was pulling more and more men into the army. Few men, who weren't officers, returned from the army. If they did come back, they were cripples. To avoid the draft temporarily, a man could get his wife pregnant since an expectant father was exempt. But the only ways to really beat the system was to sneak out of the country, the route my brothers had taken, or to become a genuine pater familias, that is, head of a large household with at least six children. So, year after year, they chugged along, Binh getting pregnant regularly and giving birth till they had a full half dozen.

Motherhood calmed and soothed my sister. She lived more socialy and quietly. The only things that might set her off were parrots squawking and babies squalling. If there was too much noise, she might flip out. To keep her sane, we took the smaller children into our house so I could watch over them. Our house was never quiet again. As soon as one child was old enough to mind his or her manners and go live with Binh, she shipped over another nursling,

Shortly after she had her last, sixth child, the government fell to the North Vietnamese. Binh's husband ended up going to the countryside to farm, and died there. Meanwhile, father also perished and we had to give up the factory and then our house. We were starving, and our uncle, who had some hidden money, was striving to get us out so as to preserve our lives. Uncle sent Binh's children with paid transporters. Binh was in such a state of shock over the loss of her husband,

she couldn't be taken on the arduous journey over the guerrilla trails into Cambodia.

As noted already, my mother, sister and brother died in an attempted escape when our boat sank. I managed to swim to another boat and, a year later, got to New York City. Three of Binh's children were adopted out of a refugee camp in Thailand by an Italian family on Long Island. When Binh's oldest daughter, Huong, was of age, she sponsored her mother to come to America. In the winter of her immigration, we met again.

3. Sleepy Hollow, New York, January 1994

Ces diverses impressions... avaient entre elles ceci de commun que je les eprouvais a la fois dans le moment actuel et dans un moment eloigne... a me faire hesiter a savoir dans lequel des deux je me trouvais.

(These diverse impressions... had among them this in common that I felt them as both the present moment and a moment far distant... so that I had to hesitate to say in which of these two moments I found myself.)

— Marcel Proust, *The Past Recaptured* [Quote added by my husband]

Late one Saturday night, when we were staying in Albany visiting, Huong told me her mother wanted to visit the Buddhist estates in Sleepy Hollow. Next morning we drove 50 miles south from Albany and, after winding past cottages and over rickety bridges, slipped through the red gate of the temple grounds.

Ice was flushed on the banks of the minimally cleared, long road leading into the compound, so we had to drive carefully. At some places, the way was clogged with lumps of snow and at others we could hear ice, like splintering wood, fracturing under our tires. All around were the stalks of barren trees, not forested so much as divvying up the ground in slightly haphazard, planted rows. The sparseness of the trees and the unbroken dusting of the snow — so thick that the creek we passed over barely cut an indentation in the waves of white — stamped the landscape as a desolate one.

It was quite a change, then, when we rounded the tide of hills and came to a sprightly, flashy, freshly painted red and yellow buildings of the monks. Buddhist practice is not to construct a temple but a temple complex with separate structures suited to the gods' different tastes. This complex had eight or nine shrines and pagodas. The four largest structures centered around a temple housing god's most famous incarnation, Gautama Buddha.

We parked and, cuffed by the wind, went up the long stairs that climbed to the main temple. The treads were sprinkled with ice so I braced Binh as we climbed. The medicine she had been prescribed to lighten her depression made her legs unreliable.

After we got in and lit incense sticks to the two-story high, laughing figurine of our heavenly guardian, Binh said she wanted to visit the Temple of Five Hundred Gods. We left my kids with my husband Jimmy and with Hong and walked to the other site.

We went in. It was as beautiful as the temples I remember from my youth. There was a small, fruit-strewn altar in the middle and on the all four walls bleachers packed with gods. They were placed on five ascending shelves, shoulder to shoulder, each one made of plaster and depicted in a seated posture, yet no one exactly the same as any other. Some were stern, some friendly looking; some distinguishable by a hand gesture, some by an ornament or jewelry or by what lay at their feet. Walking around as I distributed incense to feed them, I felt myself in the sightline of so many gazes.

Binh had wandered over to as corner and then she stood there so long I went to see what she was thinking. Speaking in Cantonese, I said, "There is no heat in here."

She didn't respond for a moment, then nodded at an effigy. "Mother prayed to this god."

I looked at him. "This god is crippled."

"Like me," Binh commented.

"You're not crippled, older sister. You just did the wrong things a long time ago." "No loy e chen" (long, long ago) was my actual phrase. The one we use to start a fairy tale.

Our visible breath was like smoke in the temple.

That night, back home, I couldn't sleep for a long time, turning thing over, resolving old hurts. Then I dreamed I was running somewhere on a burning surface, knowing the self-burden of fire.

Chapter 4
My Father's Last Concubine

1. An-Dong Market, Saigon, May 1965

My mother commonly traveled with two outriggers, maids who accompanied her when she went food shopping. You might say we were rich since my father, Thanh Chung, owned a noodle factory with 200 workers, but mother still shopped, cooked and cleaned with our five maids, four of whom ran our in-house shop. But that day, the maids stayed home and as she examined kitchen utensils, she later said to me, she was alone.

The An-Dong Market was like a gigantic, partially shaded oval. The outdoor part of the circle sold sweets, vegetables and fast food while inside, under a vast dome, were innumerable stalls retailing meat, bowls, clothes, dead people's money, incense, just everything.

Mother had paused at a cross piece between two internal aisles to examine some fancy chopsticks when she overheard a fish merchant remarking, "There's Mrs. Chung. Her husband is very rich. He owns a noodle factory."

Mother looked up pleased, then displeased: pleased to be recognized, displeased when she saw the merchant was not talking about her, didn't recognize her, but was referring to a jauntily dressed, 19-year-old girl, who was passing by, dragging a little daughter.

Not till mother got home did she find in her hand six, red lacquer chopsticks.

2. Saigon, 1960s

One thing about the Cholon district of Saigon in the 1960s through the early '70s, it lacked men. A war was going on so young males were continually drafted. As soon as a boy reached 14, he was put in the army. No one could escape.

Or almost no one. One of my brothers was born very weak and could barely do any chores. He was too weak to be sent out of the country, so we found a place for him to hide in the attic. South Vietnamese soldiers would show up unexpectedly at 1 a.m. and search the house to find young men but my brother was so well hidden, he escaped detection.

My three healthy brothers went to Hong Kong as stowaways on military transport vessels when they were 12 years old. It cost 1 million Vietnamese money to bribe the army for passage on a ship. Given that a white-collar wage at that time was $4,000 a month (Vietnamese money), you can imagine how much that cost. We borrowed money from our rich uncle to make up some of the price.

If you went into the military, you either died on the battle field or lost a leg or two legs or an eye.

As noted previously, because of this situation, there were no men. Women had very little chance to find a husband or a boyfriend, so it was very normal for a man to collect one, two, three wives and even a few mistresses. In Vietnam, polygamy was legal and a man could legally marry ten times. Even a man pulling a sik lo (rickshaw), the type who would eat a morning meal of a slice of bread and a banana, and whose clothes were full of patches, would have two or three wives, all with kids. He didn't have to take care of his women. A woman would go to work in a factory or sell fish in the market to provide for her children. It was ingrained in us, in Chinese culture, that it was our obligation as women to carry on the family name. As these women saw it, having a husband was a nicety that could be dispensed with if necessary as long as they had children.

Perhaps the most notorious example I met of a man having many women was the so-called King of Binh Tay. Here's how I met him.

When I graduated high school, I began to work with my father at the factory, which was a 90 minute drive from our house. (Remember all my able brothers had departed to HK.) I had to deliver noodles to various places, including to the king. He had acquired the name because he had seven wives. He was about 50 and owned a big business and a large mansion. I found out that each wife was in charge of one thing. One does the cooking, one the cleaning, one the bookkeeping and so on. Each had one bedroom and each night of the week he would stay with a different one.

The chauffeur would drive the van to bring the noodles, accompanied by me and one worker who would unload them. I asked the

chauffeur why these ladies don't fight. He told me, "If one fights, he will kick her out and get a new one. That's how he got the latest one." She was an 18-year-old girl who had just graduated high school.

In those days, a man was considered the master of the household. Some Vietnamese men were very violent. More than once, I saw a man chase a woman and beat her with a stick on the open street. No police or passerby would interfere. Of course, the man would not beat the woman to death but just to the point of injury so she would get a lesson. Chinese men would seldom do this, beat a wife, but they still had control over women.

My father was not so blatant as the king, who kept a whole harem, but he couldn't resist the overtures of attractive women. Because he was very successful, and had power and money, and because he was tall, good-looking and good-natured, he had many chances to meet women. Holding such a high position as a factory owner, he had to go out almost every night to socialize with other businessmen, such as engineers from Taiwan, contractors from HK and Vietnamese military men. Not only did he go out to dinner frequently, but he had to make trips to Japan, Taiwan and other places. On his trips and when out on the town, he was bound to meet women, women of all sorts. Years later, my mother showed me pictures of my father with a Japanese woman and with one from Hong Kong, taken on his trips.

At that time, middle class women were not independent. They stayed home to raise the children (we had seven), cook and clean. So, though, my mother knew her husband had many women, she didn't have much to say, because he was the breadwinner and made decisions in everything.

When my mother encountered father's mistress Hoa (flower), who was shamelessly masquerading as the legitimate Mrs. Chung in the market, she didn't take any action. At the time, I was 12 years old, but if I'd been older I would have told mama to act like Mrs. Chu Lau.

Mr. Chu was my father's chauffeur, and like my father (and later me), he stayed all week at the factory. He must have been lonely. At the time there was a Vietnamese woman, Nam, who cooked and supervised the cooking of the meals for the workers, who ate in the canteen. She was younger and prettier than Chu's wife and had a small house right outside the factory gates. And don't forget, Vietnamese women liked to get Chinese men because they have money and don't beat their wives. Nam and Chu had an affair.

This happened before I was living at the factory, so I scarcely would have known anything about it except that one afternoon Mrs. Chu came to our house to talk to my mother. She said she'd found out that her husband had another women with whom he'd had two children whom he kept hidden in the factory compound. She was angry and wanted to know what my mother had to say about it. Why, she wanted to know, did my father allow such things to happen. Mother, lying, protested innocence, saying she knew nothing about it.

That answer, as you can imagine, was not satisfactory to Mrs. Chu. She took the recourse that many other Chinese wives had chosen. Next week, father reported, she suddenly appeared at Nam's front door, screaming like a mad ghost, cursing Nam for stealing someone else's husband and shaming her in front of her neighbors.

I thought my mother should do the same thing, but I couldn't advise her. In Chinese culture, a 12-year-old girl can't tell her mother to attack her father.

3. Thu-Duc, July 1972

One hot afternoon when I sat in the factory office, our van came putt-putting over the pebbles that formed the factory compound's street, running between the workplace and the workers' dorm.

This struck me as odd since father didn't allow anyone but me, him, our foreman or the chauffeur to drive the vehicle and all of these men were sitting within my sight.

I ran outside, closely followed by my father, who was fluttering along like an agitated butterfly. A smartly dressed, slightly chubby young woman climbed out of the van then shifted out two young kids, five or six years old.

My father, right behind me, said to the young girl, as if trying to introduce us, "Hoa, call her auntie."

I didn't open my voice. I was so angry.

I had heard about this woman many times. This is the one who stole the love from my mother.

I walked away, took my way to the other side of the compound and went into the shower room, becoming more and more furious. I had heard, yes, my father had another woman out there, but I didn't imagine she had the nerve to show off in front of me.

I was thinking, "How dare you come to my territory."

Yet, I couldn't confront her in front of my father. It had been drilled into me never to attack seniors. So, instead, I walked into a shower stall and stopped, looking up at the nozzle, like a dummy, as if it were that which produced all the water on my face.

4. Saigon, 1970s

Among all these women my father had, I only met that one. She is the last woman of my father before he died. She was younger than my older sister. Hoa was a waitress in the restaurant where my father dined with other businessmen. She was 16 when they began the affair. I was eight years old.

My mother didn't uncover this affair until after Hoa had a few children by father. She found out Hoa was living in our neighborhood and father even bought her a house. We didn't have a house! We rented.

I guess you think my mother was very stupid, that she didn't know her husband had a mistress till she had five or six children. You see, she did know her husband fooled around, but not that he had anything long term. At first my mother kept her mouth closed, but then she'd had too much.

One day two little girls, one about five, one about ten, came to our house, looking for "papa." They were Hoa's kids. Father ran out and took them home. When he got back to our "rented" home, mother yelled at him, furiously, "Doesn't this woman have any shame?"

Father tried to explain — I was eavesdropping — "It was an accident." He said he was drunk and they started an affair. Then they had children and now it was too late. How could he break up with her now, he asked. Could they kill the children?

My father was getting more and more upset. He was not like the King of Binh Tay, who could control multiple women. Confucius says that all one's relationships have to be in harmony for the family and nation to prosper. Those children coming to our house created an unbalance. Father said, lamely, that he told Hoa never to do that, never to send her children to our house, but she didn't listen.

Who can say, but perhaps this contributed its small part to the breakdown of everything else in South Vietnam. The economy collapsed and the communists took over the country.

✿ ✿ ✿

After the war, the government seized the factory, shut it down and did an inventory. The soldiers came and recorded everything, every desk, every machine. They told us that if anything were lost, we would be responsible so we had to live in the factory and keep an eye on things. Father had to attend daily self-criticism sessions. As I noted earlier, a young secretary from our factory, Hue, who never got the promotion father promised her, now accused him of being a reactionary and of having hidden gold. They kept this up for weeks, hounding him to reveal where the gold was hidden. Finally, he had a heart attack and entered the hospital. After that, they left him alone.

5. Thu-Duc, August 1976

I wish I could make a pilgrimage to that great, broad-flanked tree that stood, bigger than anything, on our factory grounds.

When I wrote this part of my memoir, I had never returned to Vietnam since escaping in 1978, but that tree with its heavy, thick greenery in the depth of summer and its thousand parasols of shade has often been in my thoughts.

After a leisurely dinner, served by Nam, the Vietnamese cook, in the empty expanse of the dining hall, clad in a thin veneer of sweat that covered our dark skin like red lacquer, father and I would retire outside to sit on our striped beach chairs under the tree, each of us holding a big gray fan, made from a large palm-like leaf.

We'd talk over the past, which, though recent, seemed separated from us by a great reef, a barrier reef, in that the Communist takeover had massively altered everything. Many of our friends had been put in jail or been sent to re-education camps in the countryside. Other had fled the country or just stayed away from us, since we had been labeled reactionaries.

Everything in the past, even a few years back, seemed far away. When I tried to think back, it was as if looking through water. Things were losing contours, details and dimensions. I say this because I want to emphasize that even the moral code by which I had lived so diligently now seemed to unfurl. Or maybe it was because, with father half-incapacitated, I was running things and became bolder.

I brought myself to broach the subject, there under the tree. I asked my father, "Why did you marry my mother?"

"I never loved her," he said simply. He told me his story then. When he came to Vietnam from China as a young man, he met her

grandmother. She kept urging him to marry her daughter, My. My mother was too unsophisticated, father said, but her relatives were rich. Besides, he said, he had a terrible weakness. He wasted money. He needed a woman who was good financially. My mother operated a fruit store. My grandmother proposed to him in mother's stead, as it were. He accepted. He wanted to continue his line, connect to a rich family, and have a good money manager. It was an arranged marriage.

"But why," I prodded, "did you have to take up with so many women?"

"Listen, Manh Nhi," he said, "in business circles ... yun joy gang wu, sun but yow gay." That's a Cantonese expression that means, "When you are in the water, the current pushes you along." That's like saying, when you are in society, there is nothing you can control. There is a trend and you have to follow the trend to survive. So, he had to go out to business parties and he met young women, and that's how sex is created. In the business circles, he said, he drank, he smoked, he had women, in other words, almost everything needed to be a bad man, he did.

I continued stubbornly, "It's still too many, too many women."

"But in that environment," he told me, "it's like when butterflies see a flower, they fly over. I have many juices like a big flower."

I frowned.

"Bok oy," he said, "I am like a god. I have a lot of love to give whoever wants."

Sometimes I hated my father. But this time, I couldn't help laughing. I couldn't get mad. I looked at him and saw he was dying. Now, he was dying, I thought, and where's all the women? Even Hoa didn't come to see him. Only my mother was serving him loyally till he died.

I guess by this time he was feeling guilty. He kept repeating, "You are too young. You may not understand."

That was our ending and soon after father died.

❖ ❖ ❖

I had no pictures of him when I came to America and, come to think of it, none of the tree. Then in 2009, 31 years after I left, my one remaining relative in Saigon sent a black and white photo of our whole circle, sitting and standing on some steps in the park. (See insert.)

I'm on the top step, 10 years old, smiling, beside my 20-year-old sister. Mother holds the baby, next to older brother. Three younger kids sit behind father, who, with hands folded, sits looking forward se-

riously, a touch disappointed. And all along the steps' side, behind and above us, the luxurious, lush bushes of Saigon, still willing to cradle us or, at least, our memory of happiness.

Chapter 5
Mei Gwok [America]

I didn't come to the U.S. in search of the American dream. I had to get out of Saigon when the Communists took power. At that moment, it was not advisable to be rich.

My father owned a noodle factory, which had then become one producing a kind of rice for soldiers when they go to war. They would get this kind of rice that you could pour water on it and it would be ready to eat, like instant noodles. We produced this rice for the military. Once in a while, American white people came to check the standard of our production.

We had started out making noodles, but then when the war came, we got a contract to make dried rice, so we stopped making noodles. This was only for soldiers. Poor people didn't have enough money to buy rice, so they would eat sweet potatoes or similar stuff. Maybe bread.

When the Communists took the factory over, they made my father manager, and set up a union in our factory, which had daily "struggle sessions." Purportedly, these meetings were to discuss current events, such as who was slacking off on the production line, but they tended to end up, as I have explained, goaded on by an irate employee, Hue, to become complaints about my father's history when it was his company. He was accused of being a "capitalist bloodsucker" and "squeezer of the workers." Hue sometimes got so worked up at these sessions, she would be hollering at him.

I knew her accusations were not true, but I didn't say anything. Quiet as a mouse and afraid to make trouble, I sat listening. No one yelled at me. I was young, a woman, and never more than a low-level supervisor. Whether father was an exploiter of the proletarian or not, he felt bad after these meetings. One night he succumbed to a heart attack.

Not only was our family devastated by the loss of our still young

head, but simultaneously the government drastically cut our rice allot-
ment. Our chances of survival were slim to none. So, aided by our
uncle, who had some money, we all tried to escape, some by land, some
by sea. My older sister Binh's children crossed the border to Thailand.
I chose the sea, losing my mother, brother and sister on the way. I
made it to a Philippine refugee camp.

From there, in 1979, I was sponsored by my half brother (the son
of my father's second wife) to come to the U.S. But he couldn't help
much. I got to New Jersey and my brother was very good to me but I
felt bad. I stayed in his house. He had to drive me everywhere. I know
how to drive in Vietnam, but in New Jersey I didn't know anything. I
stayed there for two weeks and I left and came to New York.

After a week with him in New Jersey, I moved to Manhattan to
live with Dr. Lee and his sister Ho Jie. Dr. Lee had come to New York
as a young man and taught a while at Columbia. Although he was no
longer teaching there, he still had an apartment in the neighborhood.
Ho Jie and I had come on the same boat and lived in the Philippine
refugee camp together. As I said, Ho Jie survived the boat capsizing
almost by a miracle. We had been acquainted before. My mom knew
her mom. We used to see Ho Jie selling cloth in the Saigon market.

Her brother at that time was going away to Taiwan for vacation, so
I was able to stay with her for one month, and after one month, I
rented a basement in Queens.

I had to find a job or a way to earn money. Eventually, I was able
to register in Chinatown Manpower at 70 Mulberry Street. They have
this training program where they offer typing, computer, accounting.
So I was able to register for the accounting program. But you have to
pass the test. They tested me in math, they tested me in English. I
failed everything. But then they call me up. "You know, since we don't
have enough people to enroll, we invite you to come in."

How lucky I was because they give you a stipend: one month, $400,
which is very good for me. You just go to school every day from 9 to 5
and you got $400 every month. I was able to pay the rent with that, buy
food with that. But clothing, one of my friends gave to me. I don't buy
any clothing. I got into an accounting class for new immigrants.

I found a place to live in Elmhurst, Queens, for $80/month. I had a
small room in a basement that had been divided into six living spaces
with Chinese couples and singles in each room. My space had a single
closet, a bed and one desk. No window, no heat. We shared the rest-

room and kitchen. A lot of poor immigrants like to live in this kind of place. The class was till 5. After class, I would come home and shop. I only buy one small chicken leg for my meal every day. Half for next day lunch and half for my dinner. After eating, I would study. The book was thick and filled with words I didn't know. I was too busy to worry.

I used to bring my lunch in a metal container. Since they didn't have a microwave at the school, I would put my rice on top the radiator to heat it up. I was quite surprised that in this class for new immigrants some of the students had been in America for 20 years! The deal was that after you completed the program, the teachers would get you a job, so a lot of unemployed people joined. All the people in the program except me were from China or Hong Kong. Of course, many knew English pretty well.

I was kept busy till the Christmas holidays when the school closed for the break. I had nowhere to go and it was cold in the unheated room. I bought a blanket. I asked the clerk if this blanket was warm enough. She said yes, but she lied. With nothing to do, no friends to spend time with it, and shivering to boot, I sat in my room contrasting life in this country to life in Vietnam. Over there, I was surrounded by people I knew, my brothers and sisters and 200 workers.

I cried because in Vietnam, my father was rich. I even had maids to iron clothing, cook. I didn't have to do anything. When I came to this country, I got nothing, no money, no close relatives. I don't speak the language. I don't know what to do.

This was the time I cried the most.

After six months, I graduated. That's another hardest part. Everybody got a job except me. It's because I was the only refugee and didn't have a green card. Instead I had a white refugee card. I went for an interview at a bank. I passed the lie detector test and the interview and the math test. But when I brought out my refugee card, a white card — it was called an I–94, I think — and they said, "What's this?"

I said, "I'm a refugee. I don't have a green card yet. That's all I have." I explained that when I was on the ship, I already registered for a green card number. They told me when you get to America, they will give you the card when the time comes, but I don't know how long.

Then they say, "I don't recognize this ID. Sorry."

They cannot hire me. Everybody in the class got a job, but I cannot get a job.

Eventually I got a job as a cashier in a Japanese gift shop, called Azuma, on 86th Street. But I don't even know the money at that time.

I remember my stepbrother had said, "I'm going to teach you how to use the money. This is a nickel. This is a dime. This is a quarter. Twenty-five pennies is a quarter." When I was under pressure dealing with Americans, I forgot what I learned. I don't even know money so how can I be a cashier?

I spent most of my time cleaning and stocking shelves. I tried to avoid being a cashier. When I was at the cash register, every time someone came in my heart beat faster because I didn't know what the customer was saying. I called Jun Ji, a Japanese guy who went to NYU. He helped me and told me I should go to college.

Then I saw every one of them working there goes to school, goes to college. I said, "Why you want to go to college?"

And they say, "We go there to get a better job. Who wants to work in a store like this?"

So I began to think I should go to college too. But first I have to get a GED, because I have nothing to prove I have a high school education. So I registered at what was called Auxiliary Services for High Schools (ASHS). It was a program within the public schools where older students could obtain this equivalency certificate. ASHS was particularly suited for older immigrants and was flexible in having bilingual classes in Chinese, French, Spanish and other languages.

I went in there because Ho Jie's brother was a teacher there (after leaving Columbia). He told me, "Come to see me and I will register you." I spent a few hours a day learning how to pass the GED program. When the summer came, the classroom was almost empty. I studied like crazy. The teacher said he never saw anyone studying so hard.

Eventually I passed, of course, because I worked hard to learn the material. I have to survive. When you have the motivation, you don't want to get starved. You have to do something. The GED is a very good program because immigrants who get here who are too old for attending high school can pass the GED test and go to college.

(After I got a GED and then a college's degree, eventually I got a job as a bilingual teacher in that same school from which I graduated. And after one year, they told me to go on the stage to give a speech to the graduates. I said, "What me?"

They said, "Tell them how you became a teacher. Tell them your story. Tell them, "If I can make it, you can make it too.")

So, next, I registered at New York City Tech, a two year college, to get an associate degree.

Meanwhile, I got a job at a Chinese takeout restaurant in a rough neighborhood in Brooklyn. Sometimes, I would get to work at dawn. It was pretty then. There was a vacant lot filled with broken bricks that in the early light looked like the last embers of a fire. If I had classes, I came to work after 2 pm.

The area was crime-ridden and volatile. Certainly, you could walk the streets unmolested, but if you ran a cash business, you were always liable to be robbed or worse. That's not hearsay. A few weeks after I started work at Happy Food Kitchen we had our first fatality. My boss was killed, stabbed to death on a Sunday night. He was working alone that night and was just closing up. When he was pulling down the shutter, this guy pushed in. The boss tried to grab the gun under the table, but too late, the guy just stabbed him constantly and ran out with the money. My boss tried to crawl out, but then he died, bled to death on the sidewalk. These takeout restaurants, I'm telling you, they are very dangerous. That's why they have the electrical automatic door that closes by itself; you don't have to go out.

There's another boss I worked with too. His nephew came from China and worked with him. This boss didn't have the electric thing on the door; it wasn't automatic. So he called the nephew to close the door. He told him that you always put $20 in your pocket, because, if they rob you, you always have money to give them. So he has the $20 in the pocket and he went out that night. I wasn't there. I heard later, He went out, somebody approached him. He gave him the money but the thief still shoots him. Later my boss told me he only heard him say, "Very painful." Just one Chinese word. "Very painful." He fell. He died. Only 28 years old with a wife and two children in China.

I don't know the situation nowadays, but when I was working in a takeout, it was very dangerous. You don't close the store until 12 o'clock and at that time not many people walk on the street. And you have to go out to close the door every night. How scary it is.

One customer had a fight with my boss. The customer said he didn't get enough chicken in his order. Later that evening, he threw a bottle with gasoline in the store, which started a big fire. Good that there's not so much damage, but it was still frightening. You don't know if the bottle might explode. I was there when it happened. I saw that. These Chinese they make a living with their lives at risk.

One time this guy ordered a chicken wing with rice and he didn't pay. He ran away. I was so naïve. I ran out and chased him. I said,

"Where's the money? You got the food; you have to give us the money."

And he just turned around and punched me right in my face. I fell and my nose started to bleed. But I was awake. I was still awake. I was conscious. I grabbed his coat and like I was saying, "Pay me. Pay me." Then he dragged me down the street, holding the jacket. And people on the street were yelling, "Help. Help." Then, I don't know how, the police came and arrested him. I went to court too. The police said, "Do you want to sue him?" and I said, "Yes, of course. He hit me on my nose."

"He was wrong in the beginning. How come you are wrong and then you hit me? You are supposed to pay me, not hit me." That's what I said in court.

To supplement my income, I had taken an additional job on Sundays at a driving school in Chinatown for people who wanted to get a license. I worked from 9 to 5 for 20 dollars. I was on the second floor and I heard a sound, BOCK, a sound like that. The police came running upstairs. Someone was shot in another office. He was the only one working and someone came in with a mask to rob him. The police came to talk to me. They scared me because I still had trouble communicating in English. I couldn't tell them much. I heard BOCK. That was it. How did I know what that sound was?

Eventually, I moved on, got my degree and, became a bilingual teacher. I married an American, raised two kids. Some people would call this achieving the golden American dream. Partly, it is. Still, there is only one time when I feel that coming to America was really worth it. That happens when I meet, maybe on the subway or the streets of Chinatown, a lost friend, someone I knew from the Manila refugee camp. When we chat for a few minutes, great waves of happiness sweep through me as if, at least in imagination, I can find room in my life for all those I left behind.

Chapter 6
St. Rita's

1. Seward Park

If things had gone a certain way, after I arrived in the U.S., I would have raised a family, bought a home in Brooklyn and spent my life working with my husband in our Chinese takeout. But my husband and I didn't get along well; he raised his hand against me, and the same night I moved out with my two young children. End of story.

Beginning of a different story. When we split up, my husband was between restaurants. The one he had owned didn't have enough business, so he was negotiating to buy another. Meanwhile, to bring in money, I had taken a job at China King restaurant in Staten Island. Every morning I took a train to Fort Hamilton, got out there and stood on the corner. The boss picked up me and another worker, and we took the highway to go to the job. So, I had an income.

When I moved out from my husband, it wasn't as if I had nowhere to go. My brother, David, had a place in Queens. As I mentioned, to escape the draft in Vietnam, at age 12 he had left the country and immigrated to Hong Kong to live with our uncle. Years later, David immigrated to New York and could help me out.

So here was my situation. I had moved in with my brother on short notice but was in a far from rosy situation. I had made the mistake of marrying the wrong husband. I had two kids and could barely support them on my China King salary.

Things go in sequences, sequences of three, the *Tao Te Ching* says. And luck goes in sequences, sequences of three. As I took the long train ride from Queens to Brooklyn, I would read the *Sing Tao* daily newspaper. In it, I saw an ad for a bilingual para to work in a class at Seward Park High School in Manhattan's Chinatown. At this point, I had been

in the U.S. a decade and before I got married, I had earned a GED at Tenzer, a public high school on the Lower East Side. I had also gotten a two-year's associate's degree from New York City Technical College.

To a knowledgeable person, it might seem funny that Seward Park needed an in-class, Chinese-speaking para. At that time, 1988, the school, located on Grand and Essex, had the largest bilingual student body in the whole city, over 2,000 students, almost all FOB (fresh off the boat) Chinese. At that date, the largest bilingual population in the city was Hispanic with Chinese coming in second. Many people don't realize that the mass immigration of Hispanics and Chinese into New York City in the 1980s did not rival, but rather surpassed the more often discussed arrival of Italians and Jews in the 1880s–1890s period.

And Mrs. Sid (as she was known), who was in charge of the bilingual program, really fought for both the students and the teachers and saw to it that most classes were taught by bilinguals. However, for some reason, there was a hole in their staffing and they could only get an English-only speaking teacher to put in charge of social studies. Therefore, they needed an in-class Chinese para to help the kids understand what he was talking about.

I applied and when they saw I had a two years college degree, I was hired right away. They were further pleased that aside from speaking Cantonese and Mandarin, I also spoke Vietnamese. They had no other paras or teachers who knew the language. Ms. Sid told me I was "excellent" and "exceptional." I love those adjectives. That's break one.

Right after I started work while I was on the train from Queens to Manhattan, reading the paper, an older woman sat next to me. Speaking in Cantonese, she said, "You look like a very friendly person. I just retired as a school teacher in Guangzhou and moved here to live with my children." She wasn't that old. As you may know, in China women generally retire at 50, men at 55.

She, Ms. Wong, went on, "Life is so boring in America. I would like to get a job. Do you know of any jobs?"

I said, "Well, I have two children and I work. I need a babysitter who could live with me, cook and take care of them. I could only pay $650 a month."

"That sounds good," she said.

"But," I continued, "I don't have much money now, so I would have to owe you."

Ms. Wong replied, "I don't need money. All my children are working and my husband is working. I just need a job."

Shortly afterwards, she moved in with me, going home Friday and coming back Sunday night to live with me and my brother, who was working as a waiter and going to school part time. I couldn't pay her for the first 18 months. However, when I became a bilingual teacher and my pay increased, I caught up her wages. That's two.

Three is that I met a good man when I was going to school at New York City Tech. He was married, as I was, and, a novelty for me, an American. We kept in touch over the phone, over the years, through both our divorces, and one day got together and married. That marriage is now past the 30-year mark. Three lucks.

I knew it would work out because after we started dating, I asked my spiritual friend what she thought. I told her what months and years we were born, and it turned out we both were water signs. She said, "Your relationship will work out. Two waters are compatible. If two woods get together, you have one big wood, one small wood. But two waters grow together, one big water."

I entered Seward Park, a new immigrant school . The students were teenagers just arrived. As I used to say, "They got off the boat and the next day they were in my class." For most, high school represented their first introduction to English, though, due to the way the system is structured, to graduate they would have to pass the same regents exams as all other students. So, in the social studies class, a few, very few, had some idea of what was going on, and most were lost. In a college paper I wrote at the time, I underlined the problem.

According to my knowledge, many Seward Park students do not even know the 26 letters of the alphabet when they enroll. The average level of these students is from 5th to 7th grade. However, they are forced to enroll in high school according to their ages, not their level. I remember one teacher complaining to me, "I am talking to myself five periods a day. I do not feel like talking to anyone else after that."

Later, I learned it was not only me who thought this strict age placement was peculiar. When I worked in elementary school, a parent would come up to me and say, "We just arrived from China this summer, and they put my son in fifth grade. But he doesn't understand English. Couldn't he be in a lower grade?"

I would say, "That's not possible. That's the rule. We can't change it."

Going back to Seward Park, you might think nobody would ever pass. However, this is why many parents toiled so many hours at low-pay jobs, so they could put their kids in private after-school and week-end tutoring programs to help them catch the level.

How we ran class was this. I would meet with the teacher, who explained what important concepts were to be discussed in the next day's lesson. He also sign-posted the key words. After reading the book for myself, I would make a sheet where the key words were paired with their Chinese equivalents. These I Xeroxed and passed out at the head of the period. When the class started, I would stand next to the teacher and translate what he said.

Although paras were not paid all that well — I made $750 a month, working the same hours as a teacher — you could see this system meant two salaries were being paid in a class which, if it had a bilingual teacher, would only have to pay one. The Board of Education is very penny-pinching when it comes to salaries, so, after a semester, this social studies teacher was replaced by a bilingual and I was reassigned to the counselor's office.

New details. The counselor in charge was Dr. Huang, a conscientious professional, so conscientious he got an ulcer from the overwork and stress. Although I would do many things in the counselor's office, including helping students select classes, translating the transcripts students brought in from their schools in China, and picking up students from their classes when they had to visit the counselor, I was primarily an outdoors para, tasked with going to visit the parents of students who were absent too much.

The indoor paras, who worked exclusively in the office, and who became my good friends, were Flora and Cammy. Flora was the older of the two, very friendly and welcoming. Sometime at lunch, which we ate in the office, she seemed half asleep and would lay her head on Cammy's desk, nearly dozing off. As I came to know her, I learned she was the oldest daughter in her family of six children and was expected to work especially hard to bring in money for household expenses. Our shift at the school was from 8 am to 2:30 pm. After work, Flora would go to her mother's house, located nearby in Chinatown, and take a halfhour nap. Then she went to Blue Cross/Blue Shield and did clerical work from 4 to 11.

Her family had fled from China to Burma during World War II. They lost all their documents so they couldn't get back into the country when the war ended, so, instead, they went to Macao, then Taiwan,

then New York City. Flora's first dream was to be a police officer and she had gone to John Jay College of Criminal Justice. There she met (and eventually married) a fellow student, who was also intent on becoming an officer. Being a cop can be dangerous and they decided between them that one cop was enough for any family, so she quit school and looked for other work, ending up at Seward Park as my mentor.

Cammy was an exceptionally bright student at the high school, who Mrs. Sid made an intern in the counseling office. A short, small-boned woman. She was a recent refugee from Fujian, who had great rapport with the students, being one of them herself. Moreover, unlike Flora and myself, she had less time to become acclimatized to American culture, and so, like the students, was closer to the Mainland in dress, speech and opinion.

Cammy was very active in organizing the biggest event of the year: China Night. This was a Friday, after-school assembly, potpourri and extravaganza that was a student talent show. There was a fan dance, a harvest dance, a streamers dance, martial arts exhibitions, students dressed as farmers telling jokes, students singing nostalgic and pop songs as well as playing instruments and putting on skits they had written themselves. It was a fast-moving, crowd-pleasing event, filled with lovely voices, the dramatic flourishes of kung-fu chops and swoops, and the closing snaps of beautifully designed fans. I would come with my children, and as we sat awaiting the show to begin, we would see Cammy bouncing up and down the aisles as quick as if she were filled with electric current.

As I was saying, the outdoor part of my job entailed visiting the homes of delinquent students. Here, I am thinking, I can use hindsight stereoscopically. I mean, it's hard to think back and remember what happened all those years ago, but luckily, I was going to school at that time, and my papers, which I can consult, were often about my students at Seward Park.

As you will see, it turns out I was a glutton for education, at least when I could go to school free, so I received Master's degrees from Seton Hall, Hunter and New York University. I was getting different education degrees, so it was often my experience as a para at Seward Park which I drew on. I will put together my memories and the memories conveyed in those papers to construct my account.

When I made a home visit, I would generally find the parents and two or three kids almost crushed by the smallness of their Chinatown

apartment. They would have two rooms: a kitchen and a bedroom. In the kitchen, there was a table with three or four chairs and a small TV on the counter. The family would cook, eat, watch TV and do homework, everything in the kitchen. The bathroom was in the building's corridor, shared by two or three families.

Their bedroom would be crammed with two bunk beds and clothing. A funny thing, by the way, was that once I went on a class trip where students visited the Lower East Side Tenement Museum. This historical heritage site allowed the students to tramp through apartments that had been restored to how they would have looked when poor Jews resided in them in the 1890s. I knew from experience that some of the students on the trip lived in places that were far worse than these.

The parents did not live in such tight spaces simply because they were impoverished. For one, they needed to live in Chinatown. That way they could walk to work and save carfare. Also, they felt safer staying in a Chinese community as they knew no English. To get a place in this neighborhood, you had to spend what we call "under-the-table money." So, for example, if a place were renting for $500 a month, you would have to pay a $5,000 bribe because there was such competition for Chinatown addresses. This meant the new immigrant family was further strapped.

In a paper I wrote for Dr. Juan Cobarrubias at Seton Hall, I add to this point by citing a book by Bernard Wong on New York's Chinatown. He argues that even though they had to put down key money, in general the immigrants would get the cheapest apartments available because, as I quoted him, "They felt it was a waste of time to spend large sums for housing when the immigrants spent most of their time at work ... [and] it was better to spend money on starting or improving a business or to hold it for an emergency than throwing it away on housing." Wong writes that the poor housing they encountered in Manhattan was "no worse than what they encountered in Hong Kong."

He adds, by the way, that this same attitude did not pertain to food. He puts it like this: "They were not stingy about spending money in Chinese restaurants or purchasing food for family consumption. The rationale for this kind of consumption was that one must maintain and improve one's health because it was the foundation for all gain-seeking activity."

Nothing I have said meant the students, though they lived on top of each other, couldn't do well in school. Cammy did. However, with

the parents often out of the house — and no one works 8 hours, it's 10 to 12 hours minimum — to supervise the children and, when the adults were home, all were crowded in the kitchen, perhaps with the mother cooking as the children did their math homework and the father watched TV, advanced learning was difficult.

And there's another interesting factor, which has to do with assimilation. As I document in my papers, "In keeping with other Chinese immigrants, these parents wanted their children to retain some Chinese culture, but they differed from other first generation Chinese by also wanting their children to obtain American education." So, I continue, "These immigrants have pressed their children to learn two cultures, often having them attend both the English language public school and then a Chinese school on weekends." Wong writes that these students "found it difficult to attend two schools (Chinese and American) at the same time."

When a student succumbed to these pressures and was playing hooky too often, I would go to his or her house and talk to the parents. The more conscientious ones would be upset. More than once it was the case that they brought their daughter or son to school in the morning and watched the youngster go in the front door. The problem was Seward Park had two entrances, and the pupil would say good-bye to his mother at one door and hello to his friends as he exited through the other.

Most of the truants were males. After they snuck out of school, they would go to Chinatown and be gambling or playing video games in an arcade. In fact, lately I was talking to a teacher I worked with for many years. I had gone to visit an old friend, who lives in Easton, Pennsylvania. My friend, let's call her Jessica, told me her brother lived near that town.

"What?" I said. "All the time I've known you, I didn't know you had a brother. And what in the world is he doing in Easton?"

Jessica explained that while they were growing up in Chinatown, he kept cutting school, gambling and getting in contact with gangsters. Her parents sent him to live with relatives out of state in order to keep him in check. Now he is a prosperous businessman.

Further documentation of why students were failing or dropping out of school comes from my college paper in the class "Seminar in Bilingual Education," taught by Dr. Leung. In this paper, I drew on my experience working in the counselor's office and said a few things that undermined certain stereotypes about Chinese behavior. While some

call the Chinese (or Asians in general) the model minority in that Chinese children often excel in school, encouraged by parents who demand their children get good grades, I found that this stereotype, as far as it is real, applies only to the middle class. While there were conscientious parents, as I just mentioned, many who were struggling with paying rent and making a bare living, thought of their children more as helpers and supplemental workers than as scholars.

This was epitomized for me by what happened every year on the open school day. As I described it then,

> Seward Park High School has more than one thousand Asian students. However, on the open school day hardly one hundred parents show up. Their excuses are either they are too busy or do not know how to get to school. The reluctant attitudes of parents discouraged their children from learning. The faculty has explained to the parents that open school day is very crucial to the student, however, most of the parents still ignore this advice. Even today, many parents believe that once the student is enrolled in the school, it the duty of teachers to educate their children and parents no longer play any part in it.

In my paper, I cite several more instances in which parents act more as a hindrance than an aid to their children's learning process. In one case:

> I asked a student why he always cut the first and second period. He said that he could not wake up in the morning. I made a home visit to investigate further and found that he had to drive his parents back home from the restaurant they worked at in Queens at 1 a.m. every night. His parents explained that since this student was the only one in the family who knew how to drive a car, he was responsible to drive his parents back home at night.

Another student had the opposite problem, not coming late to school but leaving early. "I found out she always cut the last period of the class because she had to pick up her younger sisters from another school. I asked her to discuss the cutting problems with her parents but she said she could not refuse to do what her mother told her to do."

I was talking about stereotypes and another one that my paper touched on was this. It is often said, perhaps wrongly, that young male students from poor neighborhoods, have their heads turned by the quest of easy money. While their parents are struggling to bring in a legitimate paycheck, these young men see drug dealers and other hustlers passing by in big cars, wearing expensive clothing and surrounded by flashy women. This turned their heads and they neglected school, imagining they can attain success more quickly by dealing drugs than by hitting books.

Chinese students at Seward Park often had similar dreams in relation to legitimate businesses. For instance, in my paper I discuss how one parent, a conscientious parent, complained to me

his son had not been studying hard since he got a job in a restaurant. The student's idea was that his boss was making a lot of money through opening the eatery. And the student told his parents that his boss does not speak English, however, he owns two big houses and a few cars. The student is looking up to his boss as a model. He believes education is not necessary for making a good living.

And some parents, the less conscientious ones, feel the same way as this student. As I wrote about a different student,

I remember one time I tried to persuade a student not to drop out of school. His explanation of why he was taking that step was that he wanted to get a job in a restaurant first and later, after he learned how to run a business, his parents said they were willing to finance him opening his own restaurant. He was told by his parents that doing business is the best way to make money.

I am quoting from my college paper, because looking back at things I wrote really helps me remember. Perhaps I should tell you how I got into college.

One day at a meeting Mrs. Sid announced that paras could take some free college courses. Twice a week, they could leave school 2½ hours early with pay so they could get to their classes at 4 pm. She said the Board of Education would pay for two courses a semester. Not to

sound too greedy, but whatever others thought of education, to me it meant dollar signs. Remember I told you that at that time, with two kids, no husband and a babysitter to support, I was financially strapped? Now, a special thing about being a para was that if you obtained a certain number of credits, your salary rose.

Tell you the truth, so far in my life I usually don't like to go to school, but, I thought, I have two kids and I have to survive. Further, I felt another benefit would be that in class I would be listening to Americans talking, which would greatly improve my English.

I enrolled in the College of New Rochelle at their downtown extension facility in Manhattan, near Chambers Street. There were many municipal workers there from my union, DC 37, I think because the city wants to further people's education. So I could take two courses in one semester, but I wanted to graduate faster so I took three courses. I paid for one course and the Board of Education paid for two courses and I worked another three years and got my BA degree.

<center>* * *</center>

I mentioned already that I had started seeing an old friend, Jimmy (as I call him, Jim Mai). This was my third luck. He could coach me on some of my studies. Still, all my relatives warned me. Sight unseen, they didn't like him.

Sometime after I had graduated from New Rochelle, Jimmy and I and our kids lived together. Then we wanted to marry. At that time I was very fresh and very naïve. My uncle said, "American men, they all are playboys." My uncle is a very old fashioned old man. "Don't marry a foreigner. They all are playboys."

"Yeah, but this guy is very nice to me," I said.

"But you can't trust these white people."

My aunt said the same thing. "Don't marry an American."

But I said, "He wants to marry me, and we lived together for a few years, and he is very nice to me, and my children need a father." So I decided to go through with it.

I told Jimmy, "You have to love my kids first. I don't care if you don't love me. But you have to love them, because they are my life." There's a Chinese saying, "If you love the owner of the house, you have to love the birds sitting on the house too."

After one divorce, I don't have much faith in marriage. I don't have

time for fooling around. We came to this country with nothing. We had to build everything from zero.

I said, "I do," but only after he answered the last question I asked him with an affirmative. My question was this: "Will you walk with me to the end of my life?"

<center>✿ ✿ ✿</center>

Jimmy helped with studying because there was just too much reading. I remember one class I took on "The Black Experience" with Professor N.J. Loftis at New Rochelle. In one semester, we had to read *Giovanni's Room, Native Son, The Invisible Man* and *If He Hollers.* So, we scheduled it this way.

Every Sunday I would leave my children with our neighbor and go to Jimmy's. (By the way, I had moved to an apartment in Bay Ridge with my brother right after starting at Seward Park because the Queens place was getting too small.) Jimmy and I would sit on the bed or the floor — he had no chairs except in the shared kitchen — and read alternate chapters out loud. I was used to reading aloud and listening to reading in the classroom since this was how things were done in Vietnam. We would read together for 5 or 6 hours as the afternoon worked its way into dusk and then twilight. I was too antsy to spend so many hours reading on my own, but this made it palatable and also helped with my pronunciation if he would remember to correct me. I would say this is when I began to fall in love.

School, school, school, until I got my Bachelor's. Meanwhile, there was a break in my work life. There were so many Chinese pouring into Seward Park that, like a Chinatown apartment, the building was just too crowded. Mrs. Sid opened an extension program at Norman Thomas H.S. Since I had the lowest seniority, I was reassigned there to help in computer class.

That meant I was separated from all my friends, well, except, because of an odd coincidence, from Flora. I recently was talking to her about our early friendship and she said, "Back in the day, we were all down-to-earth types."

"I don't know what you mean," I said.

"Nowadays, everyone's nosy and wants to get in your business," she explained. "But those days, we didn't inquire about each other's personal things. I didn't even know where you lived."

"After work, I didn't know where you went, because I walked to my mother's to take a nap. And you were an early bird, too. You left at 7 to go to work, and I left at 7:30."

"Once I took a day off from my second job and was going directly home. I saw you on the R train. I asked, Where you get off?"

"Bay Ridge Avenue." "What street you live?"

"68th."

"So as I," I said. "What number?"

"488."

"I'm at 486. We're neighbors We can see each other, building to building, back to back."

She was right about that. I had a window from my third-floor bedroom into an airshaft, from which I could see to her second-floor, adjoining building window. One part she did get wrong though was my time of leaving for work. It was not 7 am but 5:30 am.

Some people, like Jimmy, thought I was crazy to get up so early. I did so because Seward Park had a pool in the basement, and the generous swimming coach, Ms. Hur, would let the staff come early and swim. I loved the water and the quiet tempo. Often I was swimming alone in the vast pool as if I had stumbled upon some abandoned reservoir, deep in the woods.

After doing my laps, I would dry off and go up to the office to eat my breakfast. I bought ham and lettuce. Not a sandwich. A piece of each. One bite of this and one bite of that. Salad is plain; ham is a little salty so it was a good balance.

Along with my friends, I also missed swimming when I got transferred uptown.

By then, I had finished my coursework, gotten my degree and was shooting to be a teacher. I took the per diem test. This gave me five years when I could teach before I had to pass all the difficult written tests to get a permanent license. Taking the per diem brings up another instance of how people keep appearing in my life.

I was getting a bilingual license so I had to pass a test on oral Cantonese. I went down to the Board of Education after work for the exam. There were a lot of applicants that day and I was the last one in. As a person was called, she or he would go into a different little room for the test. It was nearly 9 pm and I was finally called, the final one. The administrator directing things from the desk outside said she was sorry I had to wait so long.

I walked into the cubicle and saw... Mrs. Sid. She is one of those go-by-the-book people, so when she saw me, she jumped up and said, "I cannot test you because you work for me."

She went out to talk to the administrator. I could hear the boss say, "Everyone else has gone home. You are the last one here. You will have to give her the test."

I am always nervous around tests, but this time I lost my nervousness. I had a per diem license but that hardly guaranteed me a job. I began going on interviews in Brooklyn and Manhattan. I had no teaching experience and, so, was repeatedly turned down

It happened that at that time bilingual education was very popular. I opened the Chinese newspaper and they had all these free master degrees paid for with a grant. Whoever is interested in bilingual education and works in a a public school can take these classes. So that's how I was able to get on. I went to two programs. One is Seton Hall University. But there I had to pay for a few courses later because I did not have that many education courses in my BA degree, so I had to pay for that. Seton Hall is a private university, very expensive. At that time, I paid $1,000 for one credit. And then, right after I graduated from that, I saw another program, also in the Chinese paper, this one was at Hunter College for special ed., also free with a grant. So I went there next. Many years later I also went to NYU, but that wasn't free, but by this time I had some money.

I went to Seton Hall University especially because, as I said about being a para, more educational credits meant a pay boost, and a teacher with a master's received a nicer check than a person without one. A Master's degree is one of the requirements to be appointed as a permanent teacher. After five years of teaching, if anyone doesn't have a Master's degree, he or she will be kicked out. I signed up for the program while continuing as a para at Norman Thomas H.S.

2. St. Rita's

Then I got a call from the Board offering me a position teaching Amerasians in the Bronx at St. Rita's. The term "Amerasians" was new to me, but it sounded like a good opportunity.

I remember going into the faculty lounge right after I had gotten the call and telling a teacher about it. She said, "Don't go there. The Bronx is the most dangerous city."

"No," I told her, "I have to do it. Let me take my chance."

I would be teaching high school, but not in a regular setting, rather in a GED program. To teach in a regular upper school, you needed a subject-area license, however, you could teach GED with any license because the students had all different levels. I was welcomed into this program by Jerry Long, Keith Honeywell, Alma Warner, Ira Berkowitz, Margaret Bing-Wade, Joanna Chin, and Sheila Evans Tranumn.

It would be a long haul from Bay Ridge, Brooklyn, to Fordam Road/Grand Concourse, Bronx. When going by subway, I would leave the house by 5:30 to get there at 7, 7:10. I rushed out of the train to eat an early breakfast. I stopped at McDonalds and drank a tea with an egg biscuit. I got on site about 7:30 and made copies for my 8 am class.

But, I'm getting ahead of myself. One formidable difficulty was that I was already taking classes in South Orange, New Jersey, getting there on the PATH train. To go to school from the Bronx, I have to buy a used car for $5,000. Before I got the car, coming from St. Rita's, I was late by a half hour and the professor was mad. "How can you come a half hour late? You missed the important points. And this is linguistics." Oh, my god, linguistics is so hard.

Luckily, I had learned to drive in Saigon. As I told you, in Vietnam, in order to avoid the draft, my brothers had snuck out of the country, leaving me the only capable young adult left in our household to assist in the family business. When I was 17, right after I finished high school, my father sent me to driving school. At that time, there was a rule for underage persons who were driving. The parent would have to sign and take full responsibility. If there was an accident, father would have to go to prison, not me.

I've mentioned, we had a factory making packaged noodles, situated in Thu Duc. If you have a factory, you have to transport a lot of goods. We had a Volkswagen bus for that purpose. Father had to stay in the factory to oversee operations and I would be the one to go to the market, which is a 20-minute drive. I would have to pick up all the lumber, things to fix pipes, and various materials we needed.

This was in the countryside, small roads, not many cars, a few buses. Most people I passed were traveling on bicycles or walking. Once, after I had been taking lessons, father went out with me, he sitting in the passenger seat, me behind the wheel. He directed me onto the bigger highway that went back to the metropolis. I was so afraid my leg was shaking. Father said, "Don't worry, Manh Yee. You only

stay in your lane. That's all you have to worry about. It doesn't matter what happens to your left or right or behind you. If anyone hits you, it's their fault. You just have to think about what is dead ahead." That calmed me.

Vietnam was a very traditional society, and at that time, 1970, very few females, almost none, were driving. And I used to dress in a very short skirt (what we called a "mini-zip") and high heels. I was a teenager and that's how we dressed. This van was very big, and a long van could carry illegal things, like weapons. There were checkpoints all along the road because the military was searching for Viet Cong; and I stood out as a woman driver and because I had a long van. As soon as I stepped out of the bus at a checkpoint, with my heels and mini-zip, there would be a lot of comments and joking. This was a Vietnamese neighborhood where the women wore long pants and long sleeves because they worked in the sun. And such dress was the Vietnamese tradition. These soldiers didn't see many Chinese wearing skirts. Plus, when I spoke Vietnamese, I had a heavy accent. These people were born and raised in the country and probably had never seen a Chinese woman in their life. As soon as I stepped down, they began smiling, joshing and joking with each other. It was all harmless but embarrassing.

To return to St. Rita's, after I took the job, I knew I needed a car. I had to put everyone to helping me. We looked at cars in Queens. When we found one that seemed okay, my brother David went and looked it over, checking the engine. Then it was Jimmy's turn. I'm not so good at directions, so I had to get in the car and let him navigate. One Sunday morning I drove the car to St. Rita's, then over a nearby bridge and on to South Orange. From South Orange, we turned around and I drove us to our apartment on 68th Street. We went upstairs and ate. Then, we got back in the car and I made the circuit again. Then a third time. That was enough for one Sunday. But we did it again the next week and again till I had it etched in my mind.

People now have GPS to help them, but years ago I remember driving in New Jersey, near sundown. There were so many cars and I remember wondering how many of those drivers were not going anywhere, but taking these same loops through the night.

I reported for duty at St. Rita's, which was a 3-story converted convent, which housed a center for Southeast Asian refugees. When I came in, I found there were two nuns working there, Sister Jean and Sister Susan, and three secretaries: one woman spoke Cambodian, one

man spoke Vietnamese, and one woman spoke both. I told them I was here to teach. I said I had been told to speak to Sister Jean, who was in charge of St. Rita's. They already had an ESL teacher, an American who didn't speak Vietnamese, and I was to be the bilingual teacher. The secretary said, "Go upstairs, that's your class."

So I went upstairs and there was a long hallway. I didn't know which was my classroom. Then I saw all kinds of people. Some older people went in this classroom, some younger in another. I looked in the room with the young people and saw that some boys, some girls, were black with curly hair. Some were white with yellow hair. I walked in and I said to myself, "Oh, I must have the wrong class. I see some black and some with white skin. I didn't know where to find my students."

So I turned around to leave and then I heard them speak Vietnamese. I said, "Oops. These must be my students." And I looked on the floor and they all have their shoes off, because in Vietnam, they don't wear shoes in the house. It's very hot. Everybody take off their shoes so they walk around barefoot.

So I said, in Vietnamese, ""Do you guys come from Vietnam?" And they say, "Yes."

As I got to know them, I found out their background not only from talking to them, but from reading articles. Sister Jean, in charge of the center, was not only an able administrator, but a good publicist. She would constantly be on the radio or in the newspaper, talking about the plight of our students. I bring this up because I can use a couple of stories from the *New York Daily News* to offer some background on these kids I was just meeting.

The first is by Betty Liu Ebron, who in the 1980s had a column called "New York's New World." In a piece called "Kids of War Find Arms of Peace" (June 26, 1992), she opens with a useful description of my new pupils.

> The children of war became outcasts after the fighting ended. Most were denied even a basic education, especially dark-skinned kids.
>
> Their crime: faces that reflect the Vietnam War.
>
> Today, seventeen years later, these grown children of Vietnamese women and American soldiers are a rainbow generation in shades of brown, beige, white and black. Some have

kinky or wavy hair. There are brunettes and reddish blonds with vaguely Asian eyes.

Scorned by Vietnam and initially ignored by the U.S., they flooded our shores by the thousands after the 1987 Amerasian Homecoming Act finally passed.

In the land of their fathers, they want to be American.

A second article in the *Daily News,* this one by Kathy Larkin (October 16, 1992), is partly an interview with Katie Kelly, a volunteer at the center. Kelly is notable in that she had been a TV correspondent on New York City's Channel 4, but gave up her job to become a good-will ambassador to Vietnam where she lived for a year, helping Amerasians. Returning home, she found out about Sister Jean's program and volunteered. She had on-the-ground perspective of the situation in Vietnam, which she described to Larkin, who asked her, "How many Ameriasians were abandoned in the rush to get out of Vietnam?"

"No one knows for sure," says Kelly.

"With no diplomatic relations between the U.S. and Vietnam, rescue efforts were left to individuals — when they could get in. Orphanages were closed; records were lost or destroyed. Even when things eased up, many American fathers didn't want to get involved. Kids are the easiest people to turn your backs on, especially these, who were so far away," Kelly explained. "And these were the children of war, growing up under a dictatorship which hated them."

Kelly also thoughtfully delineates the circumstances of their arrival as Larkin tells readers:

"With the Amerasian Homecoming Act of March 1987, the doors of the country opened. But for thousands of youngsters, it was no easy transition. 'It was a culture shock,' notes Kelly. "These are older kids with no job skills, no experience, no English. They're just completely bewildered by everything. They identified so strongly with their American halves that they expected everyone would be lining up at the shoreline waiting to welcome them."

Instead, they were often discriminated against again — this time because of their Vietnamese heritage.

Adds Kelly:

> "The government just cuts them loose once they get over here. In fact, every Amerasian who arrives in this country in thong sandals and T-shirt owes someone $700 for airfare, a one-way ticket from a refugee camp. It's welcome to America. You owe money. You are an American."

In some cases, the situation was even worse than Kelly describes. As a 19-year-old student told me, when this Homecoming Act was announced in Vietnam, he was sold to a rich woman. The rule was that if you have one Amerasian in the family, the whole family can come. This boy's own family was very poor and had to give him up. The boy said his mother was crying. She told him, "I have no money. You go out with this family. You will have a future."

Some future. As soon as he arrived here with his new family, they threw him out. Luckily, he quickly got a job at a Chinese restaurant, found a place to stay and began going to night school. But he deeply missed his true mother.

I am not implying that all children sold had it this bad. On the contrary, some were bought by parents who wanted children from mothers who didn't want them.

I can speak with some in-depth knowledge here simply because when I was at Hunter College getting my second Master's I wrote a paper for Dr. Theresa Ying Hsu's class "History-Asian Origin," for which I conducted multiple interview with both one of my Amerasian students at St. Rita's, Phong, and his elderly, adoptive parents.

Here was the case where the mother rejected the child. To quote from my interview,

> Phong's real mother was abandoned by her American serviceman boyfriend when he found out that she was pregnant. The real mother had drunken medicine to abort the baby but this method had been unsuccessful. I questioned the adoptive mother further on this point. I asked, "Why didn't she get an abortion from a doctor?"

"Those are very expensive in Vietnam. She had no money. She could only buy the medicine"

She went on to give me more details on the birth and adoption. "It was a premature birth. He was born at seven months. The baby had to be kept in the hospital for a month to sustain his life."

She explained that the mother did not want the child and so the new mother, who could not have any children, took the child in and helped the mother with financial aid. She explained that they were overjoyed to have the child. I asked her to say more about why.

"It's because the child brought us very good luck. My husband got a promotion at the police stations soon after we took the baby in. And he began to make a lot of money."

In the paper, I then questioned the father more about how this money came in.

...he confessed that the greater amount of money he was earning was due to a share of the police station's extortion. He said, "If a person wanted to make a large purchase, such as of a house or a factory, the person would have to have the purchase validated at the police station. Customarily, people who wanted their papers processed in due time had to pay a bribe to the police division."

As you can gather, these new parents adopted Phong while the Americans were still in charge of the city, so you can see they took him in with no idea of profiting from him later as a possible sponsor to enter the U.S.

They were hoping to send him to school, but the world changed when the U.S. pulled out of the country. They still tried to get him an education, but found this to be impossible. Here is what was said when I interviewed the mother,

"Phong went to school through the second grade but it got too dangerous. His father used to pick him up after school, but it was not always possible for him to get there exactly on time. However, when he got there late, the bullies waylaid Phong and beat him up."

"Why?" I asked.

"Because he has American blood. They hated that because they hate Americans after what they did to our country."

When the war was over and the Communists took over, Phong's new father was sentenced to six years in a concentration/work camp in the south because he had been a policeman. He emphasized that again he was lucky not to be sent to the north. As he put it, "No one ever comes back from there. It's too cold and we don't have the clothes to live there. They have you digging up unexploded bombs that were dropped by the Americans. Such a life is short."

Once Phong's father got back from the camp, they lived as best they could till they heard about the new law allowing Amerasians and their parents to emigrate. They decided to apply although it ended up leaving them in a financial fix.

They applied to leave. However, the Communist government being every bit as corrupt as the former South Vietnamese one, the couple discovered it would take a considerable amount of money to get their emigration papers validated.

"Thần tài [The God of Wealth] smiled down us," the mother told me. "We found someone who wanted to buy our house. He paid us a number of gold bars and moved in."

"What did you do next?" I asked.

"We lived with our relatives and with the money we obtained we were able to pay the government to pass on our papers. We got our airplane tickets and were to leave on the following day. Suddenly we were called for an immediate interview at a government agency. We were very fearful. The man there told us that the government had decided they wanted our house. A general wanted it. We protested that we had already sold it. They told us that was too bad but that whoever was there would have to move out by 6 a.m. the next morning.

"We were frantic," the mother went on. "We couldn't return the money to the new tenants because we had already spent all those bars of gold in paying off the government."

"So what could you do?" I wondered.

"We went to the new owners and told them the whole story. We begged them to forgive us but told them our situ-

ation. We didn't have the money to repay them but promised to send them the money back once we reached America.

"They were very kind people and they were willing to trust us. They said they would move out of the house immediately. Thus we were able to leave as planned."

In my Hunter College paper I had mentioned that these parents might be called welfare cheats. I said on our first meeting I had found the parents were both taking welfare, but "because the welfare payments were low, the parents worked from 50 to 60 hours a week (seven days a week, eight to ten hours a day) sewing clothes. Because they are on welfare and are not supposed to work, their jobs are off the books. They are paid by the piece and make an income below the minimum wage."

Don't forget, the father was 67 years old, the mother, 60, and yet they were putting in 50 hour work weeks. And, in writing about them, I had learned why they exerted themselves so much. As I put it, "Now I understood why they worked so many hours each week, often staying up all night to complete a job. They had a debt of honor to discharge. They told me that in the year they had been here, they had already sent back $1,500 to the people who had bought and then so suddenly lost their home.

They were sewing garments at home for a Vietnamese contractor. In fact, on my visit to the Tenement Museum when I worked at Seward Park, they discussed such "sweatshop labor," which I believe is more prominent today in New York than it was in the 1890s. It took an outlay of funds to get started. Once, on entering their apartment, "I asked about their sewing machines. They said each cost $750. These were a necessary investment because they could not make a living with good machines. However, these weren't the best machines. They explained that once they had paid off their debt to the people in Vietnam, they would save for the better machines, which cost $2,000. This would make work easier."

Having described this family, who had adopted an Amerasian that no one else wanted, let me return to two other things Liu Ebron said. She mentioned that when these Amerasians were in Vietnam, they were "scorned" and that "most were denied even a basic education." It might be thought that these facts are connected. Perhaps because they were looked down upon, the Amerasians were not allowed to go to school. We've seen already that this is not true as Phong did try to go to school.

A more pertinent point might be that in Vietnam all schooling costs money. Even to go to kindergarten, you have to pay, so very many Vietnamese, Amerasians or not, never went to school simply for that reason. And to continue Liu Ebron's point, in Vietnam, Amerasians were looked down on by people. They looked so different. Wherever they go, they are not welcome. People feel they are not coming from a normal family; either the mother was a prostitute or had an affair with an American.

That was the prejudice although it was not always true. I remember one family that had four kids in my school: one black, one white, one Hispanic and one Asian, all from the same mother. Their mother was not a prostitute. She was a very good cook and so she got a job at an American army base in the kitchen. The way I see it, she is friendly and pretty, and the soldiers must be lonely. I don't understand exactly what happened but I know the soldiers changed shifts every year, so she ended up with these kids.

This was one of the most united families I ever came across. Every year they used to have a big birthday party in their apartment in the Bronx. They would take all of the furniture out of the main room, lay a big tablecloth down, and we would all sit on the floor and enjoy a terrific meal of such dishes as chicken meat with cabbage, bean sprouts and curry. All the children loved each other despite their different exteriors.

Let me say a little more about the Amerasians' life in Vietnam and initial reactions to the U.S., this time drawing not on my own papers, but that of my colleague. I said there was one other Board of Ed teacher in St. Rita's, and he, like so many younger public school teachers, was also taking night courses. When I talked to him about my book, he mentioned he had written a paper for Dr. Judith Pasamanick in which he included some autobiographical essays by his Amerasian students, the ones in the advanced class. In them, they talked a little about their life in Vietnam and their feeling about entrance into the U.S. I asked Jim if I might borrow these papers from him for use in my memoir because I thought it might be nice to hear some of the Amerasians' own words about their experience

Amerasian My Hanh Nguyen explains how her life changed when the Communists took over the south.

I was six years old. The first time I had gone to kindergarten. I could read newspapers and books. And every day my

father read a book for me to write dictation. I was unhappy because I studied only two years. In 1975, I was eight year old. I wasn't going to school because the Communists came. My father wasn't working in the factory. My family was poor and, though I was only eight years old, I had to take care of three younger sisters and one brother. My parents had to go to work all day long.

She says that under the Communists, her family had to change from city work to country work. "In 1977 my father became a farmer. My family had a farm. I was ten years old. I couldn't help my father work, but I could take care of my sisters and brothers. Sometimes I fed the ducks, chickens and rabbits. At the farm there were many big trees and my mother planted flowers."

Once the new law allowed them to come to the U.S., the family made a first stop in the Philippines, which was a halfway house for all new Vietnamese immigrants making the trip. Here they would stay in a refugee camp in order to be given English lessons and some preparation for life in America

My Hanh tells the story:

In 1988, on September 12, my family left Vietnam for the Philippines. We lived in the Philippines about 10 months. The life was poor because the camp was small and very crowded. Eight to ten people lived in one house in the same two bedrooms. Sometimes there was no light. The weather was very hot and there not enough water to take a bath or to wash clothes. Sometime I had to bring the clothes to the stream and wash. Sometime I went to the woods and mountains to get some bamboo and trees to make the fence in my garden.

School in Vietnam was not easy, certainly, as Nguyen Khanh attests. "In Vietnam I liked to go to school a lot and I like to play too. Sometimes I hated school because when I didn't know a word the teacher would take a ruler to hit my hand. That was why I didn't like school in Vietnam."

Parents also got into the act to discipline bad learners, as Nguyen Thi My Ha explains in describing her family's school experience in Vietnam.

About 1978 my family left Long Thanh and came to Tay Ninh. My father and my mother were farmers again, my sister stayed at home with my younger brother. My sister Hanh cooked for the family; she didn't go to school. My younger brother stayed home because he can't speak and can't hear. Only two younger sisters and I went to school. We didn't want to [go to] school. My father always hit us because we didn't want to study.

The trip to America was welcomed by all these students. Nguyen Khanh states, "One day my mother and I took an airplane and went straight to America. That's when I was small and didn't know anything. But one thing. I am like American boys so that nobody makes fun of me." Ha gives more details about his arrival.

The first day I sat on the airplane I looked down at the United States. It's a big country. I had never seen it before. Next time the airplane just came down. The first time I saw the airport I was surprised because in Viet Nam we have an airport but it's smaller. It's not the same as the one here. Later on we took a big car. They put us in the car and started to run. I had to pass [a] long bridge. Now we live in the Bronx. My address is 686 Rosewood St.

From these testimonies, it's evident that, though life in the U.S. is hard for them, life in Vietnam was harder and so all embraced their new fortune with optimism.

To return to my thoughts about schooling, not all of the Amerasians lacked education. If the families could afford it, the children had gone to school, but they were laughingstocks and had to endure a lot of insults and beatings. However, most of them had never set foot in a classroom before they arrived at St. Rita's.

This may be something it's hard for people to appreciate. Even if at the school in your native country you might not have learned any English, having some knowledge of school is important. Many students in Seward Park, those fresh off the boat, had zero English, but they did know how to read and write Chinese. I believe that if a pupil has practiced reading and writing — whether of alphabets or ideograms, that part doesn't matter — the child gets something like a handhold that

will serve her or him when learning a new language, even if it involves a new graphic system. And the illiterate miss out on this and it is harder to start learning from scratch. This was the difficulty one faced with the Amerasians, few of whom could read or write in any language. This was one challenge for me.

But, there was an even bigger challenge.... I didn't know how to speak Vietnamese. Wait, I know I'm exaggerating. Here's the situation. I had been in New York for ten years, living and working exclusively within the Chinese community. I don't know that I used Vietnamese once in that decade. It was going to be an uphill struggle to reconnect to this rusty tongue and my forgotten heritage.

I bought a Vietnamese/English dictionary for $45, quite expensive, and used it to help me translate what I was going to teach.

As I mentioned, I came in early to Xerox because, once the secretaries got in, they would be using the copier all day. This was busy site, with a number of social programs, besides the English classes.

The Board of Ed had no books in Vietnamese, so I took a simple grade school book and, at home, wrote Vietnamese words and sentences next to the English ones. Then, still at home the night before, I made up a sheet with the outstanding words in the unit in English and Vietnamese. In the school, I copied all these things before class.

As I said, there were two teachers, Jim Ferraiuolo and myself, and two classes. In the morning, I taught the basic class. First, I wrote the words from the vocabulary list on the board, and the students would copy these into their notebooks after they got settled. Then we would go through the lesson, slowly, patiently. The book pages I copied would be something simple with big words and a nice pictures.

That class ran from 8 to 11. Then it was lunchtime.

We went down to the kitchen where there were benches and tables.

The students got a school lunch and I ate my own. This was last night's meal, cooked by Ms. Wong. There was some rice in there; some meat in there, some vegetables. I heated it up in the stove.

In the afternoon, I took the advanced class, which consisted of the few students, maybe three, who had gone to high school in Vietnam. They were usually the most Asian looking, who could pass for pure bloods. The basic class had about eighteen students.

For the afternoon class, I employed more advanced materials, even elementary school books sometimes. For them, I didn't have to Xerox so much. Both classes were filled with students who were hungry for

knowledge. They very much wanted to know America and speak like Americans. Tell you the truth, it wasn't till years later when this school closed and I was transferred to Chinatown Manpower to hold a class there, that I had a great awakening. Until then I didn't know there were students who were not eager to learn.

I think I should say something about my associates at the center. On top was Sister Jean. Kathy Larkin describes the center and how Sister Jean started it. St. Rita's is "a resettlement agency with Vietnamese-speaking volunteers, an alternate high school, adult education classes and a job placement office. St. Rita's was started by Sister Jean Marshall 10 years ago to help Cambodian refugees. Eventually, the Cambodian immigrants tapered off, and were replaced by Amerasians."

Betty Liu Ebron says something about how hard Sister Jean struggled to hold the place together. St. Rita's, she says, "is the only resource for Amerasians in the entire city, the place to learn English, job skills and a sense of community."

Sister Jean gets so little funding, the center survives on daily miracles. Somehow she serves 6,000 people a year and finds enough small grants and $15-to-$50 donations to meet her $350,000 budget.

Ebron goes on, quoting Sister Jean:

"I decided to help them for a few years," she says, "Well, ho, ho, ho. And here I am nine years later."
Sister Jean is very funny but she doesn't laugh enough
She's chained to the phone, begging and battling for money —
and fighting tears of exhausted frustration.

Sister Jean's office handled so many problems that arose in the interface between the new immigrants and all the city agencies with which they were involved. I remember once a Cambodian mother (who didn't speak any English) was accused of child abuse by a school teacher, who had found horizontal marks, looking like bruises, on the woman's daughter's back.

This is a prime example of cultures' mutual incomprehension. There is an Asian home remedy, called gow yaw in Cantonese, that is something like cupping in that it brings blood to the skin's surface. In

gow yaw, the healer takes a small object (such as a coin or, in my house, a spoon or ladle) and draws it vigorously across the patient's back, going from the spine outward on both side, with strokes away from the heart. This is done repeatedly till a red welt appears as a line. Then a second line is drawn, lower down. At the end, a series of bands go down the back. I've had this done to me as an adult and can say it doesn't hurt, but feels as if someone is forcefully massaging you.

You can imagine, to the teacher who saw the marks, it appeared as if the child had been whipped, and it was up to Sister Jean's Cambodian secretary to go down to the elementary school and explain this peculiar (to Americans) cultural practice.

Every day there was a mini-crisis at the center, something that had to be dealt with immediately; yet, still, thinking back and trying to picture her, I don't see our director as harried and mired in problems, but cheery and laughing at some party or celebration for the students.

Sister Jean made a big deal of Christmas. Christians are like that. She said the pupils needed to know about American holidays, so every student got a song sheet and had to learn the carols. During the week before Christmas, everything was interrupted for part of the day when we would assemble in the kitchen, where we sat in a circle and learned the music. Come Christmas Eve day and we could go downstairs and all raise our voices together. "Silent Night" was a favorite song, as I remember, but the most loved piece was "The Twelve Days of Christmas," because it repeats again and again so it's easy to learn. Also, the students recognized the rhythm. It's one that is similar to that of a Vietnamese pop song, so everybody caught on quick. After the songs were sung, Sister Jean distributed presents to all the students, not the red pockets Vietnamese give out at New Year's, but nice little items such as combs and scarves.

These were the happy times that made everyone love America.

The second teacher, Jim Ferraiuolo, perhaps because his parents were racially mixed, showed great sympathy for the Amerasian students. While he didn't speak a word of Vietnamese, I think his musical background made him delight in the beautiful tones of the pupils' native speech. Jim was a trained, well trained, reed player, proficient on flute, oboe, clarinet and saxophone, having taken degrees at Manhattan School of Music and the Mannes School. It was hard to make a living in the profession, he told me, but he was so skilled on his instruments that I was always surprised when he would occasionally tell me that he

had had been called in as a sub in the pit for an evening performance of a Broadway show. On weekends, he was often hired by big churches that were putting on sacred concerts. We went to one at a church in Fort Greene where the ensemble performed Handel's *Messiah*. He also taught music at night at York College.

Jim did really well with the smaller, advanced class, as you have seen by the quotes I have used from his student's papers. He would use a more freewheeling approach to pedagogy than I did in my class where we concentrated on reading and reciting. He would have the students do role playing, which was a great way for them to increase their fluency. A student would pretend he or she was asking directions, going to the doctor or in an American restaurant ordering. The Amerasians would also discuss their own lives, how they handled their families and daily encounters.

Jim is a big-hearted man. He, like me, had to take a long trip to school, training in from Brooklyn every day. Frequently, he made the same journey on weekends to attend student's birthdays or weddings.

Beyond teachers and staff, St. Rita's also collected some colorful volunteers, and I'm talking about serious, hardcore helpers who came every day to aid us, arriving at 8 am as we did and working with us throughout the day.

Our first volunteer was Bob, a retired high school librarian, who was moved to come to St. Rita's by hearing about it on the radio. As I recall, he often focused on individual tutoring with promising but struggling students. I remember, for instance, that he worked successfully with a boy who eventually obtained his GED and went on to graduate from a two-year college.

This shows a volunteer can make such a difference that, without him or her, the affected student would have had a totally different, probably less fulfilled life. Not to praise myself but to make a point, let me say that after I retired a couple of years ago, I volunteer (no pay) a few days a week at P.S. 160, the school where I taught for nine years. How can retirees sit home when students need help, I'll never know.

A second full-time volunteer, one I got to know better because he eventually was hired as a para, was Jack.

Both Bob and Jack said that listening to a radio program about St. Rita's had stirred them to action, not only because they felt for the plight of the kids, but because they were lastingly ashamed about the Vietnam War and how the U.S. had intruded (to their minds) in the country so

violently and unnecessarily. If I remember correctly, in the 1960s Bob had viewed from afar all the protests and peace vigils held by anti-war activists, not able to bring himself to march in the street. This was one of the biggest regrets in his life. By helping so selflessly at St. Rita's, he was, in some odd way, making a karmic repair in his life history.

Jack may have shared similar feelings, I don't know. He was a complex figure. He grew up and went to art school in Maine, later supporting himself, as many artists do, by carpentry and home renovation. His best friend from art school — this was in the late 1940s — moved to New York City. The friend became involved in Abstract Expressionism, moved up the hierarchy and, eventually became, if not a leading light of the movement, at least well enough recognized that he went from his impoverished upbringing to millionaire status.

As an aside, let me say that I, know nothing about art, but do have an affinity for artists. Years later, when I was teaching in Chinatown, I used to go on Saturday and Sunday to join one of the groups that did early morning tai chi in Sarah Roosevelt Park.

And I want to mention here that tai chi has always been significant in my life. To step back a moment, you might remember when I was on the ship, waiting to get to the U.S., I had a persistent cough. I also knew people in my ship, who were not allowed to come to America because they have lung disease. When I came out of the ship and I was in a Manila refugee camp, every morning I would get out of the bed early and I go up to a little hill and start to do tai chi and breathe the fresh air. I think I was kind of healthy because of that.

I learned tai chi in Vietnam when I was about 19, 20 but then, when I came here, I didn't have any time, I was too busy with job and family but when the pressure eased, I went back to tai chi I think that it saved me, so I should really keep it.

In the park, the group was mainly Chinese, of course, but also attending were a number of Americans who lived near the park. One I was introduced to as a "tai chi fanatic" was Pat Passlof. After some years, I learned she was a well-known painter as was her late husband Milton Resnick.

The group was led by Jenny, who lived down near the water by the (now gone) Pathmark. Every weekend morning, she would drag her little cart with her tape player inside. Then she would assemble us in the park. We would begin with warm-ups: loosen the neck; then the shoulder, front and back; knees, inside-out, left-right; the legs, kick up and down, side

kick. Limbering up took about 20 minutes. Then we did sword, fan, and two types of tai chi fist. All in all, it took about two hours.

After class, we would go to Pat's house to use the restroom and sometimes go out to lunch. We all became friends, and some tai chi classmates and I were even driven by her to her second house in the Catskills. Driven once, and once was enough, as she had as little regard for the rules of the road as she did for the conventional rules of painting. We stayed overnight in her place. She showed us her late husband's room, which had paintings everywhere. Her whole house was crammed with great art.

We got up early the next morning and did tai chi on the big lawn in front of the house, facing all the beautiful scenes of nature.

Pat was no dabbler but a serious practitioner in our circle. Later I read an interview where she connected her productivity as a painter to her sincere devotion to tai chi.

At one time, the high point of our Christmas season was Pat's annual Christmas party. In the first floor "loft" in her building, which was rented by a fellow artist friend, they would have placed all the sculptures to the side to make room. Mounds of food, much of it home-cooked by Chinese in the tai chi club, were spread around: plates of fried rice, Hainan chicken, Chinese broccoli, all kinds of good eats. There was a table in the back with wine and there was beer in the fridge. Also, in the back are was counter chock full of pastries, cakes, "don tats" (Chinese custards), pie slices and fruits for dessert.

There were chairs scattered around the loft, but it was so crowded that most people just stood around with their plates in their hands, talking, waiting for the main event. This was the Christmas play, written and staged by Pat and the tai chi club. It was an uproarious event, not so much for the acting and singing but for the outrageous costumes: reindeers whose antlers were wrapped with flashing neon Christmas bulbs, Santa Claus in a handmade green suit, and a bunch of middle-aged Asian women dressed up like elves.

Everyone stayed too late and drank too much.

(I did meet quite a few artists in my life. One was the incredible abstract painter, Yuko Otomo, who helped me so much in conceiving this book. Then there's her husband Steve Dalachinsky, the forceful collagist and poet. Then the path-breaking artist Shalom, with his talking, shambling robot golems. And my dear friend, Richard Brown Lethem, who moved long ago to Maine and became our guide to artistic activities there.

I go to L.A. often to visit family, and yet I have never glimpsed a movie star, maybe because everyone is driving a car, but in New York, you can't turn around without falling over celebrities.)

To return to Jack, his friend invited him down to New York, introducing him into the social whirl of parties, gallery openings, and networking. One thing Jack became adamant about when we discussed this was that he couldn't stand the hustle and bustle, couldn't stand trying to ingratiate himself to dealers and buyers as he made the rounds of cocktail parties, get-togethers, and pre-openings viewings. Plus, he didn't drink, which hindered his socializing. So he chose a separate life path. He returned to Maine, got married and settled down, painting the outside of houses for a living rather than the inside canvases that might have sat on walls.

So many years ago. However, things changed as he grew older. His liver was damaged by inhaling the paint fumes over all those years of working and, when his kids were grown, his marriage soured and he separated from his wife. If I recall rightly, he met an Asian woman, his age, who was up in Maine for a yoga retreat. She managed a number of properties in New York City and, after they had gotten together, he moved down here to help her with renovations and live in one of her vacant places. However, he didn't have enough to occupy him full time. By chance, he made another redirection in his life path when he heard a radio broadcast about St. Rita's and presented himself at our door to become our second full-time volunteer.

Jack was not well-off at this time so, not long after he arrived, I petitioned Sister Jean to get him money to pay for his subway tokens. He proved incredibly patient with the kids, as Bob was, but he also was adaptable. If records on a student's progress had to be filled in, he did that. If a pupil needed individualized tutoring, he helped there. If a bracketed book shelf fell down, he put it back up. Moreover, his artist's skills proved precious to us. I would be talking about, say, animals of the world and putting their names on the board. He would illustrate by putting lively chalk drawings up to stalk around my letters. Indeed, to go further, once I had to give a presentation in a class I was taking at Hunter, which involved Chinese ideograms. Jack volunteered to help. I wrote the Chinese expressions on a piece of paper and, with his exquisite script, he copied them on a pasteboard. I don't know how many non-Chinese could so faithfully reproduce our language.

Even more, as years went by, Jack would occasionally come to my house and do handyman things, such as fixing a lock on our door.

After a year volunteering, Jack became a para. We made a good team. When St. Rita's closed, we went together to work at Chinatown Manpower, where there were just two of us in this off-site classroom, and then on to Tenzer Center on the Lower East Side, where Jack began working with all the teachers.

The third volunteer, our most celebrated one, was Katie Kelly. Like Jack, later in life, she too made an abrupt career transformation. This part I don't have to base on my memory of conversations with her, but on a book she wrote, whose long title itself reveals her trajectory, *A Year in Saigon: How I Gave Up My Glitzy Job in Television to Have the Time of My Life Teaching Amerasian Kids in Vietnam.*

As she explores in this book, her first brush with Amerasians occurred on a tourist visit to Vietnam. As she begins her memoir:

> It seemed insignificant at the time. I saw a pretty young girl in front of me. She had brown wavy hair, hazel eyes, and a scattering of freckles across her nose. She looked like a high school senior on her way to cheerleading practice.... Then she asked if I wanted to buy some postcards and I was knocked back to reality. Intellectually I knew where I was, but standing there and looking at the smiling all-American face in front of me confused me. I was in Vietnam and she was an Amerasian. Her name was Kim and little did I know that moment would change my life.

Kelly was a journalist, having started on the entertainment beat for *Time* magazine. Eventually, after writing about TV for print publication, as she states, "I landed a job on television. In 1978, I became the on-air entertainment critic for WNBC-TV, the local NBC affiliate in New York." She worked for the station for over 10 years before she took her fateful Vietnam trip, the experience of which stayed, at first in the back of, then moved to the front of her mind. Mentally, the thought of Kim and Kim's plight keep entering her consciousness. "Gradually," she wrote, "it became more and more apparent that what I really wanted to do was go back to Vietnam and work with Amerasians."

As I've noted, in 1987 a law was passed that allowed Amerasians to emigrate to the U.S. The exact procedure was that, after the processing of their papers, the accepted refugees would go to a refugee camp in the Philippines where they stayed for six months, learning English

and getting schooled in American customs. Kelly's brainstorm came after she read about and then met an American vet who had established "a halfway house in Saigon for them homeless Amerasians he had seen there." Katie Kelly decided:

> the vet's idea to shelter as many of these homeless Amerasians as he could and my [new] idea to start teaching them English in preparations for their eventual relocation to the United States seemed a perfect match. So I threw in my lot with him and his project, and with a great deal of confidence, I quit the cushy job of mine and announced to family and friends that I was leaving NBC, leaving New York, leaving the country to go to Vietnam to teach school.

Her actual time in Saigon, recounted in the book, was a bumpy one. Once she got there, she found the GI's halfway house had closed, but she had not been informed. Ever plucky, she set up shop in the government-run Amerasian Transit Center, under the eyes of a (at least temporarily) benign center supervisor. However, such a set-up was not to last. A higher-up cancelled her permission to hold classes there, so she adjourned to the top floor apartment of an Amerasian whose family was slightly better off than most others. (One family literally lived under a staircase.)

I've quoted the very first page of her book, so, to explain what happened when she got back to the States, let me quote from the last. She writes:

> Meanwhile, through some of the nuns I had met while serving Thanksgiving dinner at St. Malachy's Church in Times Square, I discovered St. Rita's Asian Center in the Bronx.... [Now] three days a week I catch the D train and go up to help tutor Amerasian students in English.

Katie Kelly didn't exaggerate about herself in her Saigon memoir. As she appears there, she will not be stopped from reaching her goal, and this goal is always one that incorporates the goals and dreams of others. Later at St. Rita's, she was equally determined to help the Amerasians any way she could, and this meant, for one, devoting herself to helping them learn English, which was exactly what the stu-

dents craved. Moreover, a point I didn't make earlier when discussing her book, not only did she teach English to the kids in Vietnam, she paid for dental work for those with crumbling teeth; bought glasses for those who had vision problems; and even got up in the middle of the night to accompany a pregnant student to the women's hospital where the student gave birth. At St. Rita's, similarly, her multiple talents were freely employed to help the beleaguered students. Apparently, a lot of strings were dangling around her for whenever a student came to her with a problem with, say, welfare, using the transit system, paying a phone bill or with a broken relationship with a loved one, she knew how to help or, if she couldn't aid the person on her own, how to find someone else who could set things right.

Her buoyant presence often energized students and staff if they happened to be in a down mood. I once said to her that she never blinked. What I meant was that no matter what the obstacle in an Amerasian's life she was confronted with, be it educational, bureaucratic, financial or emotional, she immediately set about overcoming it. Like Sister Jean, Katie was a person who could always be relied on, a rock, my rock. Whenever I felt overwhelmed by the multiplying responsibilities of teaching, going to school, driving a long distance, and raising kids, she would find a way to 1) catch my eye and 2) make me laugh or at least raise a smile.

These were our wonderful volunteers.

As I said, we didn't only teach our students but participated in their daily lives by attending birthdays, weddings and other parties. I remember especially the very first wedding we attended. When we got to the building, my children were already grumbling because we had spent so much time weaving around these snaking streets of Norwood to find a parking place. When we got to the student's door in the apartment building where the wedding was to be held, we found all the furniture out in the hall as if they were being evicted. This was done so as to make room. A few large tablecloths had been spread on the floor around which the guests would sit to eat.

First, though, the ceremony. While most of the furniture had been removed, more had been brought in to construct an elaborate altar, full of statues and flowers. A lay religious person presided over a brief ceremony. This struck me as peculiarly Vietnamese as Chinese would not have a representative of religion at a wedding.

After they briefly pledged their love, we ate, settled on the floor, and chatted. There were wonderful dishes: spring rolls (homemade), curry chicken noodle, beef noodle, cabbage chicken, and sauce. The Chinese use either soy or oyster sauce on everything but for the Vietnamese it's fish sauce. There was also, to top it off, fruit, egg custard and black bean dessert, with everything washed down with plenty of beer.

I can't say if most high school teachers go to their students' marriages and parties, but for me attendance was very affecting in that it was as much a way to get in touch with Vietnamese life as it was about enjoying time with students. I already said, in relation to language, in New York I had become rooted in a purely Chinese culture and had lost some of my facility speaking Vietnamese, and, equally so, I lost my involvement in Vietnamese society. Going to all these social occasions helped me to reintegrate my two heritages, and so put me back in connection to my upbringing.

As I came home from this first students' wedding I attended, I thought back to my sister Binh's marriage in 1965 which happened when I was 12 years old. It was also held in our house. If you were rich, you could have a wedding in a restaurant, but we were a humble family. As I said, there was no ritual, no religious ceremony. The Chinese say that monks were for people who die. They shouldn't be involved in marriages. We registered the union with the government and then threw a party.

Binh got so many presents. My mother gave her a big bed; a red, big blanket; and two pillows embroidered with a beautiful scene, showing a boy and girl, holding toys and staring wide-eyed at two yellow dogs, boy and girl, who were dressed in wedding garments. On the top was sewn "Sweet Dream" (in English). She got a new pink dress with sparkly inlays that made it shiny, white high heeled shoes and a few necklaces and rings. Our cousin, My Ngan, who now lives in Maryland, was her assistant, helping her get dressed and put on makeup. People brought red envelopes with lucky money for the happy couple. For the occasion, each "red pocket" had a pine needle affixed to it to symbolize long life.

Don't forget that even though she was all fixed up with new clothes, makeup and styled hair, as is customary, the bride cannot walk out of her room to where the guests are outside eating. Binh did come out before dinner to take pictures and say hello to the guests, but then she had to go back upstairs.

We had two tables in the house, each sitting ten to twelve people. The food was ordered from outside, all vegetables, for a Buddhist repast. (A vegetarian banquet is not typical, but I guess that's what the couple wanted.)

It was a joyous, memorable event and, I remember, that Binh was heartbroken, years later, after the Communists took over and mother had her sell all her rings and jewelry to buy food when we were starving.

3. *Miss Saigon* and Vietnamese Memories

There's one more major event I should talk about that I attended with the students. I mentioned already the irony of one of the field trips we made at Seward Park. The students went to the Tenement Museum to see recreations of the cramped, airless dwellings of the Jews who lived on the Lower East Side at the turn of the 19th century. The irony here was that these reconstructed apartments were more or less the same as if not superior to those the Chinese students were living in now.

Something similar went on when our Amerasian students were given free tickets to see the Broadway show, *Miss Saigon*, that first opened at that time in New York City in April 1991.

From reading the *Sing Tao* Chinese paper, I could see that this ticket offering was something of a political ploy, using my students in the same cynical way they had been used by both the Vietnamese and American governments numerous times. As the paper reported, the Asian community was staging boycotts and picketing the play because the lead Asian male actor, supposedly a Vietnamese tout, was played by a European with makeup to give him a darker skin color. The Asian protesters compared this to Hollywood's notorious Charlie Chan films of the 1930s in which the Chinese detective was impersonated by a Swedish actor with toothpicks "slanting" his eyes. While the producers of *Miss Saigon* had no intention of changing their racist casting, as a way to dampen the tensions in the Asian community, they gave out free tickets to all manners of Asian groups. We were one of the beneficiaries.

All that said, we did have a jolly time at the show, which was filled with singing, dancing and helicopters. Along with the students I had never been to a Broadway show. And it was about Amerasians. Neither I nor the students could follow all the zigzags of the plot. It was hard enough to follow spoken English, let alone when it was sung.

Basically, a GI in Saigon during the war gets a bar girl pregnant, then abandons her. He comes back to find her years later when she had moved to a bar in Bangkok, but now the American has a wife to whom he is devoted. Since the Vietnamese lady, Kim has a kid, she begs her ex-lover to take the child, not her, back to the U.S. The wife refuses, saying the little boy needs his birth mother. (You can see the story gets more far-fetched as it goes along.) So, Kim kills herself so her son will be brought to "the golden mountain."

I learned this by reading about the play, not watching it. The spectacle — and maybe it was designed this way — was almost too much to take in. There were quieter, purer moments, this is true, as when the GI, Chris, declares his sudden love for Kim, who lies sleeping. But it was almost as if the whole show experience, me being in the large theater with well-dressed people all around me, and the students beside me, who kept whispering as they tried to explain what was going on to each other, and all the pyrotechnics, dancing and sexy costumes on the stage, made the performance somehow both super exciting and yet hard to really to watch with attention.

This doesn't mean that the students couldn't follow the broader outlines of the drama. The message, by the end, seemed to be that an Amerasian must leave her or his mother (family) behind if the individual really wants to enter the U.S. And this they knew was fundamentally untrue. Here's the irony I talked about a moment ago. Even those Amerasians sold to other families, and being so handled was very much the exception, were still closely tied to their relatives and the broader Vietnamese immigrant community. So, ironically, they couldn't understand much of *Miss Saigon* because of the language barrier, but if they could have understood it, they would have seen how alien and false its message was.

I looked on the story more sympathetically. As I understood it, much of the action took place in the red-light district where GIs meet prostitutes. To me, soldiers know they may die tomorrow so why not enjoy tonight. I guess in those days with the war going on, there were not many jobs so women did this kind of work.

To get back to the spectacle itself, the only time when I became solidly transfixed by what was taking place onstage — and this was all the students talked about on the subway home — was the descent and rise of the helicopter, which was portraying the last minute air lift of American personnel from the U.S. Saigon embassy in 1975 as the Viet Cong closed in. When the rescue happens on stage, Kim and other

Vietnamese who are longing to escape are outside a cyclone fence, pushed back or down (when they try to climb) by MPs inside. Suddenly there is a sound of wings, of rotor blades whirring as, through the murky dusk and an overlay of fog, the helicopter drops down, its two headlights blinding the viewers. For a moment, the Vietnamese escapees fall to the ground in silence as if in worship, but as soon as the craft sets down, they are back up, clamoring to be let on board.

This is all very interesting. I think the wives of American soldiers and other hangers-on must have known about this airlift and that's how they knew to show up at the embassy, but no one I knew living in Saigon at that time ever heard of it. In fact, once when I was visiting my niece Ah Phong in Vietnam, I mentioned this story to her. She must have been about 15 at the time of this evacuation. My mention drew a blank stare. She knew nothing about it, didn't know it happened. It seemed to me odd that an incident which Americans revere as an iconic moment in the war is one that no Vietnamese ever heard of.

However, the more important reason I bring this up is because it points to the divergence between my perception of *Miss Saigon* and that of my students. Being in the U.S. for ten years, I had encountered this image of the helicopter escape numerous times on TV or other places. I was becoming assimilated, which I found involves, as a small part of it, learning what odd ways the mainstream views your culture. That's Americanization.

My students were still unassimilated and so the helicopter was merely a tool that created excitement and pleasure, but for me, it measured how far I had been immersed in this Western culture so that I could now retrieve my memories of the downfall of Saigon and balance them against what I thought of as the American version.

In my experience of that time, it's not as if everyone who could, that is everyone who had a connection to the U.S., wasn't trying to escape, but that this was going on for weeks before the final exit. I mentioned already, everybody tried to get out at the airport, but you had to have an American take you. If you worked for an American company, you could come out with your family. On the TV news, I saw the picture of an American with ten Chinese or Vietnamese, probably Vietnamese, following behind him.

My neighbors, whose daughter Bick was later engaged to my brother, had a cousin who worked at the American embassy, so that whole family got out. In fact, both my left and right neighbors got out.

Bick's family was on the right. My left-hand side neighbor's sister married an American, not a GI, but a teacher at the English language school I attended, so they all flew out.

I guess these neighbors were afraid that by having family associated with Americans, they would be at risk when the Communists took over. We weren't worried about that since we didn't have any connections to them but we didn't know what to expect. Aside from seeing army trucks pass, packed with soldiers waving the Communist flag, at first there wasn't much of a change.

Once the North was in charge, as a complement to people fleeing, other people started to come back. One neighbor, as I remember her name was Hoa, was a young woman who had joined the Viet Cong. Her mother didn't even know. Each night Hoa told her that she was going out to study when she was really going to practice shooting and other things the Communists did to prepare. One night the soldiers came and arrested her. Under her bed they found a cache of rifles. She was taken to prison. After the war, she returned. They had beaten her so she was partly paralyzed and had to go around in a wheelchair. She came back a hero but her life was over.

Maybe I should add that, living in the U.S., I not only saw how the Americans pictured the war, but, from my time in St. Rita's, I met many people from Vietnam, whom, once the Communists imposed their harsh rule, tried to escape.

Earlier I said that my brother escaped by paying to leave on a ship, a military transport. After the war, it became much more difficult to leave. I met a man who tried to escape seven times. He would get out of prison, try again. Another person I met, who was caught twice, learned Chinese in prison He was one of the few Vietnamese that risked his life trying to escape. Almost everyone else in prison was Chinese.

Someone I met more recently was caught five or six times. On his last attempt, he was apprehended but his brother made it. Years later, his brother sponsored him to come to the U.S. I told him, it is your fate to come by plane, not by boat like me.

My students, once here, went their own ways. Many opened nail stores, in fact, most all of them did. The most successful opened his first store in the Bronx, then moved to New Jersey. He became a millionaire.

I guess you could say, one learns backward. Or, maybe, better, learning is like parking a car, something I wasn't good at. You move the car forward, just as I was learning to be a teacher, with St. Rita's as

my proving ground. Then you move the car a little back just as, in working with the Amerasians, I was rediscovering my ties to the Vietnamese language and culture. And remembering these ties itself had two layers. Sometimes, I thought back to childhood experiences and sometimes I updated my sense of Saigon by hearing news of the city from the students who had resided there long after I left.

St. Rita's, valuable to the students, valuable to the teacher.

In Katie Kelly's book, she has what she calls epiphanies. For instance, when she made the major decision to give up her cushy TV job to go to be a teacher in Vietnam, she was prompted by a sudden, blazing insight, ignited by a meeting with an Amerasian.

I've never had such epiphanies. I don't think a Buddhist can have those. The idea of enlightenment in our tradition is that at the moment of insight you get a better, truer grasp of reality, not that you change your lifestyle, although, of course, you might. To go further, the idea of enlightenment in Chinese Buddhism, which I practice, is even narrower than that in other sects, and its concept shouldn't be confused with the satori and world consciousness experienced in other traditions. The only thing it can be fruitfully confused with is the Western idea of death. This idea, as I understand it, is that at the moment of final closure, a person's life, a woman's life, say, flashes before her eyes, and she looks back on everything she has done. In Chinese Buddhist enlightenment, the woman does not die, not at all, but the process is similar. There is an inflection, a momentary inflection, which allows her to see everything that has gone before in a special way, in a special light.

I can't say the helicopter scene in *Miss Saigon* produced that revelatory sensation in me, but I do know that my years at St. Rita's brought me into contact with this light so that I could in the Buddhist sense know myself. This means that I could know the three generations: my parents and my sister; myself and my husband; my children, all one in my life's core.

Chapter 7
Tattoo

In late 1983, I had the bottom of my eyes tattooed with one line, a dark line.

Someone asked me to tell this story for a book, which has yet to come out, so I am doing that now. My first husband and I ran a restaurant called Wing Fat (Cantonese for "always prosperous") in a tough neighborhood, Sutter Avenue, Brooklyn. We were robbed numerous times. It took me a while to realize it wasn't smart to argue with thieves. As I mentioned, once, when my husband was out, I ran down the street chasing a customer who failed to pay for his order of chicken wings. When I grabbed his coat, he punched me in the head, knocking me to the ground.

I was working hard. We were open every day from 11am to 11 pm, and lived in a small room in the back of the restaurant. However, I took some time off because I was going on nine months pregnant with my daughter Ana.

One day during that time I took a trip to Manhattan's Chinatown and noticed a new store called Tin Lai on Bayard Street. They advertised a process to make your eyes look bigger. Tin Lai translated literally means "heaven's angel," hinting that if you undergo this process, you will look just like an angel. By the way, Tin Lai is also a Chinese first name (like Angie or Angel) and this was the name of the owner who did my tattoo.

This was the company's very first store. Now they have many branches. Just open a New York Chinese newspaper and you'll see it is filled with advertisements for the service. They've even opened a school teaching tattooing and facials. Tin Lai, the woman who waited on me the first day, is so rich she doesn't have to work in a store anymore.

At that time I felt my eye is only medium-sized and I wanted bigger, so I just walked in.

Tin Lai was tall, with big bones, and she spoke only Cantonese. I asked her about the tattooing. She mentioned they also do the eyebrow.

In that process, they shave off your eyebrows and tattoo in new ones. That's very popular now.

The price for one line under the eye was $1,000! A lot of money, but, remember, at the time, she had the only shop in New York doing this. Right now the price is down to $200. She explained her price included two years' service. I could come back anytime in that period and have my tattoo touched up for free. It seems these tattoos tend to fade and, she said, a lot of people come back four or five times in those two years.

Before I'd met my husband and gotten married, I'd been working at Azuma and had saved $5,000. This was my own separate money and I didn't tell him about it. I decided to withdraw some for this treatment. It looked good at first, but it did fade. With having my daughter and going back to work, I never had time to get a touch up.

She did the tattooing with what looked like a pen with a needle at the tip, which pokes into the skin. It must have worked automatically 'cause it kept coming down. I felt it was not very painful, but it was painful. It's like you wish it would stop very fast cause you don't know how long you can last. The tattooing seemed to stretch on and on but it must have taken a half hour or 45 minutes.

After it was done, Tin Lai said I shouldn't be exposed to the sun for one week. If I went out, I should wear a hat. She also gave me an ointment to put on. My eyes swelled up for two weeks. I didn't want to go out and see people. So that was that.

I forgot about my tattoo, till, years later, with a new husband and when my kids finished college, in 2009 I went to visit my uncle in L.A. About an hour south of Pasadena is the small city of Westminster. Its population is 40 percent Vietnamese, said to be the highest concentration in the state. My husband Jimmy and I decided to drive down and take a look. We parked in the lot of a large Vietnamese mall and got out to walk around. We found one store that did massage, beauty treatments and eye tattooing. The last procedure was just $199.99.

I went in to check it out. The proprietor, Huong, was chubby and very friendly. She kept talking — she spoke only Vietnamese — to distract me from the pain once I settled on getting a new tattoo. She told me, soothingly, "Your husband will not recognize you. You will be a different person. He will be crazy about you."

My original purpose on entering the shop was to see about removing the dark spots from my face, the type that appear when one ages, but we began talking about tattooing. My bottom eye liner tattoo was more or less invisible by this time. I decided to try the top. This was a good decision because I find I like the top much better. My eyes look bigger.

During the process, Huong and I fell to comparing notes. I mentioned that in New York only a few people get lines tattooed over or under their eyes. Most people do their eyebrows, shaving them off and having the tattoos placed there. It's done by women who find their natural eyebrows ugly or if there's not too much hair.

Huong said in California eyebrow-replacement tattoos are also the most popular. It's also quite popular in Australia. (In fact, I was later to learn that my old friend Ah Gay had this done on her in Sydney.) In Vietnam, Huong went on, most women have tattooed eyebrows. Some look very nice, but if the stylist does not do a good job, it can look atrocious. She said that can always tell at a glance if a person had their eyebrow done because when an eyebrow is real, it is not that dark, but a tattooed one is really dark.

I had a good experience with Huong. Now that my upper eyelid is tattooed, I look more alert. But one thing I didn't expect was that the color is blue. I had supposed that it would be black as had been my lower eye tattoo. But she didn't ask me what color I liked, she just did it.

The key point in all this is for me to look alert. I don't care about looking pretty. Some people think of a beautiful woman as a flower vase. And a lot of women try to match this ideal of female loveliness. Now when you talk to a woman, you look at her face. Unless you're rude, you don't look her up and down or, say, look at her shoes. So, the face has to be good.

Women who chase the ideal and those with nothing to do will spend tons of money to look pretty. You know, that's the easiest money to make, to sell cosmetics. Many women don't eat well or dress that well, but, for them, the face has got to be pretty.

Another reason people wear makeup is because they feel it's necessary for their job. Western woman put on lipstick when they work so as to look professional.

I don't work at an office but at an elementary school with little kids. People there don't care what you wear as long as you don't expose your body or do something like wear pajamas. And they don't expect you to wear makeup and act like you're going to a party, as long

as you are on the ball. As I said, I don't try to look professional, but I do want to give the impression I am alert and ready to work.

Nor do I try to be beautiful. I'm not the kind of person who spends time in front of a mirror. I value the person that has something accomplished, not an outside face. You were born to be pretty or not, but if you accomplish something on your own, that's considered more worthy. That's me.

Still, I did listen when Huong said my new tattoos would make my husband love me even more, but Jimmy said that's not possible.

Chapter 8
One Day (June 28, 2011)

[A small publisher, now out of business, once asked me to write something for a pamphlet in which you recounted one day in your life. Long story, but after teaching at St. Rita's, Chinatown Manpower (where I had first studied accounting) and Tenzer Center (where I had once gotten my GED), I ended up at the wonderful elementary school in Brooklyn, PS 160. I will say more about this last school in the final section.]

When I opened my eyes Tuesday, it seemed like every other workday till it dawned on me: It was the last day of school. I felt a great release.

I made my oatmeal breakfast and left a bowl for my husband, fed the cat, then steamed last night's leftovers. I do that to make them soft, so this way when I get to school, I only have to put them in the microwave one minute, not five. I don't want to keep them there too long because the microwave is not healthy.

I get dressed, turning on the lights and making a lot of noise in the bedroom, none of which rouses my husband. He sleeps like a pig. I take the D train and get to work at 8:10 am. As I approached the school, PS 160, I could see a lot of kids were bringing flowers and bags of gifts for their teachers.

I moved my time card and started upstairs to the ESL office. As a pull-out teacher, who moves from class to class working with small groups, I don't have my own room. I was stopped partway up the first staircase by shouts of "Miss Chung. Miss Chung." It was one of my third graders, Iris, who had bought me a small bouquet made of crepe paper and lollipops. She was also carrying a gift for Ms. Tai, who teaches her brother. (The students got wind that Mr. Molter was leaving and bought him six ties!)

I went upstairs. I'll tell you a secret. On the last day scarcely anyone teaches. Because it's a half day, we have the first lunch at 10

am, the second at 10:30 and the last at 11:00. At 11:30, we pack up and walk downstairs.

By now most everything has already been done. All the bulletin boards have been taken down; all the books put up in the closets. Some classes are having an end-of-term party with the students and teachers bringing cupcakes; in others students are telling the teachers about their summer plans, and in still others, they are drawing pictures.

We pull-out teachers busy ourselves straightening the common room, dusting and shredding papers (practice tests, minutes of meetings and so on). Everything — books, papers, and supplies — has to be put up on shelves so they can wax the floors. We are a merry crew, all talking, cleaning and sneezing. Some classroom teachers drop by to say goodbye, and some substitutes also stop in. They are mostly depressed because the Chancellor has announced they will be greatly cutting substitutes next year.

Over all this, our super-competent principal, Ms. Russo, is making constant announcements over the PA. "All papers with students' names on them that are being discarded must be shredded. Please return all books to the library. Remember to give out report cards today. Lock all computers. Return all door keys to the principal's office."

When things were stowed away, I went to lunch with Victoria Groccia, another ESL teacher. She is a very pretty woman. When I first saw her I thought she was coming from ancient times, like the women I saw in movies about the Tang Dynasty. She has thick hair, white skin, and a curvy body. When I first met her, I said, "I imagine you don't belong to this age." She is always smiling, pleasant, greeting people with "How do you feel? How was your trip?" Victoria is a very dedicated teacher, always working, always focused.

She wanted me to accompany her to the store where she was exchanging the birthday gift she had gotten Mr. Roberson. It was a decoration for him to hang on his cell phone, but since his phone didn't have the necessary hook, she said she would get him something else. Mr. Roberson is very active. He knows how to play kung fu, which he learned when teaching in Korea, and he even organized a dragon boat crew. He's very good in computers and very disciplined. He even spends his lunch time working with students to prepare them for the NYSESLAT test.

Victoria and I ate in the park before going shopping. "Miss Chung. Miss Chung. What are you doing here?" A lot of my students came running up. They are all happy: chattering like magpies, eating ice

cream like polar bears and jumping rope like gazelles. Their moms sat on the benches looking at their report cards.

After eating, Victoria and I walked to Eighth Avenue, exchanged the gift and hurried back, though we managed to miss the beginning of the end-term meeting. For most people that wasn't as important as what followed: distribution of the five summer pay checks. Everyone was rushing and jostling to be first in line while Ms. Russo was hollering. "Alphabetical order. You must be in alphabetical order." And for many of us, the next thing was even more important: the last day party.

When the school day was ended, Ms. Quiles drove Ms. Tai, Joey and me to Bensonhurst. Ms. Quiles is the ESL coordinator, but though she's in charge, she acts like a regular colleague. She is very encouraging, always saying, "If you have any questions, don't hesitate to ask." She stays in school till 5 every day. I'm talking about no pay, just working. And as she comes to school in the morning she's always pulling a little luggage, like the Mainland Chinese women you see in Hong Kong. She needs it because she does a lot of paperwork.

Ms. Tai is the only Chinese teacher we have who comes from China, so her Chinese is the best among all of us in the school. The rest of us come from Hong Kong or Vietnam, so we don't have the proper Chinese education. Ms. Tai speaks perfect Mandarin. She is thinner than me and has very big eyes. Joey is the school aide in charge of attendance. I don't know her well but she is always pleasant and smiling.

When we arrived, we saw the place was packed with teachers. Outside where we took four big tables, we could see PS 69 already had one corner. Inside by the bar were another two schools.

A disclaimer. I am going to describe two parties on the last two Fridays of the semester, so that you might get the impression that elementary school teachers are a sub species of the party animal whose drinking habits fall somewhere between those of riverboat gamblers and Triad members. That's not true. Such bacchanals as I'm describing occur only twice a year, at the end of each semester at which time there is usually enough steam to let off as would heat the Trump Towers.

That evening I sat with the other ESL teachers, Ms. Quiles, Ms. Tai, Joey, and later Victoria. But everyone kept getting up and moving to different tables. When they asked me what I wanted to drink, I said I'd have what the other ladies were having, "Orange juice and Walker." (Confession: I didn't know Walker was alcohol. I thought it was something like seltzer.)

"Hey, wait a minute," Mr. Lauro interrupted. He was afraid I would get drunk like I did at Mr. Molter's going-away party last week. Truthfully, I have small experience with drinking and I didn't recognize it when another teacher spiked my orange juice with vodka. I didn't eat anything and got woozy, nearly tumbling off my bar stool. This time Mr. Molter had my back. He got me a chicken crepe.

A little background. When I was working for my father in Vietnam, we would always have these lieutenants and sergeants walking around there to look things over. Once they finished inspection, father would have to entertain them so he invited them to a club. He would hire one beautiful woman to serve drinks and he always asked me to come and drink to show my respect as the daughter of the owner. Eventually, I got sick of all that drinking and the doctor told me I was damaging my liver. I stopped drinking and didn't touch alcohol for more than 30 years. Now, occasionally, I would have a little sip.

While I was knoshing, Ms. Quiles was saying, "Eat that. Eat that. Do you want anything else?" Then, Mr. Molter, who is so generous, bought a pizza for each table.

It seemed that at this week's party the main topic of conversation was last week's going-away party. Mr. Lauro asked me, "Did you get in trouble with your husband when you showed up soused?"

"Well," I said, "I met him at the gym and he noticed I'd been drinking. Then we were on the train. I tell him never to sit next to me on the train."

"Why?"

"Because, as we're a mixed couple, people stare at us like we're aliens. So, he was sitting across from me, and he kept peeking at me from behind his book. I guess he thought I'd do something crazy. Which I did. I yelled out, 'Don't stare at me.'"

Victoria asked me how I got so drunk so quickly. I said, "Well, Mr. Lauro was pouring for everybody. I was eating a lot of popcorn. I was thirsty. They know I don't drink. So when I started sipping the orange juice, I said, 'Why is this so bitter?' And Mr. Molter said, 'That's how it tastes when it's fresh.' So I drank it in one big gulp like I drink water.

"Mr. Lauro turned around, saw the glass was empty and asked, 'Where did it go?' He thought I poured it on the floor. I drank two more and Mr. Molter asked me why I drank them, since I normally don't drink. I said, 'I drank them for two reasons. One is to say goodbye to you, Mr. Molter. And second, I drank to salute you, Mr. Molter. You work so hard. You come early for chess club and you stay late for

environment club. And now you are buying drinks all around and spending money on others. I can't pour your drink on the floor. This is your sweat and blood."

" 'I'm proud of you, Miss Chung,' he said."

Mr. Lauro is a third grade teacher who loves sports a lot. He likes to wear a Yankees shirt. He is a big, friendly guy who is the earliest to get to the school and the last to leave. He runs two clubs, including the chess one, which he leads to the city competition, and every year it gets an award because we always win.

Ms. Quiles said, "This time we won't let you get drunk. We don't want your husband looking at you."

They had tried to get me to sit between Mr. Molter and Mr. Lauro, two bad, bad boys, but I said no. "I'll sit by Ms. Quiles and she will protect me. I don't trust you two. You are dangerous."

Mr. Molter helped me a lot when I started when I followed him for three days to see how he operated as an ESL teacher. I call him Mr. Perfect because he has a very handsome look, a fit body, and he works hard. I joke around saying, "If I was younger, I would have grabbed you before you met your wife."

We began talking more about the eventful school year with all its ups and downs. This year the school had improved its rating and everyone was happy about that.

Later, Mr. Lauro turned to me and asked sincerely, "Nancy, how old were you when you came to the U.S.?"

"20."

"And how many years have you been here in the U.S.?"

I said, "I'm not answering. Are you trying to trick me?"

Mr. Lauro was laughing. "She's not drunk yet."

However, in trying to protect me, Ms. Quiles herself had gotten a bit intoxicated. She had to leave her car there and call her husband to come and pick her up in his car.

I left about the same time, and beat my husband home by a few minutes. When he walked in the door, he asked me how I was. He looked suspicious. "I'm not drunk," I told him.

"Then why are you going to bed at 9 o'clock."

"I didn't say I was sober."

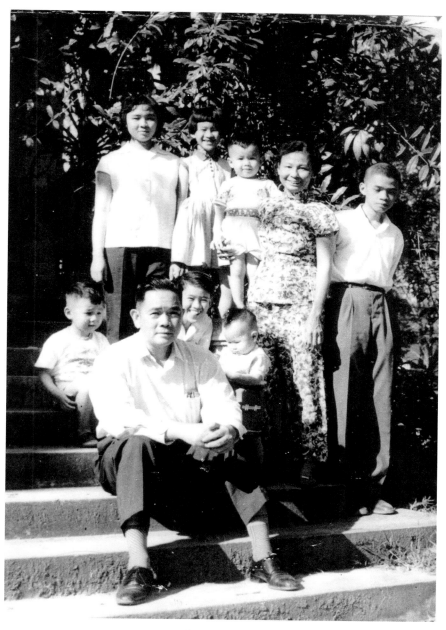

Chung Family
(clockwise from upper left):
Binh, Nhi, Bao, Mother, Chieu, Warren, Casey, Father, and David

Nhi in Vietnam (clockwise from upper left):
Portrait; in Hue; at Dragon Gate, Father's Factory

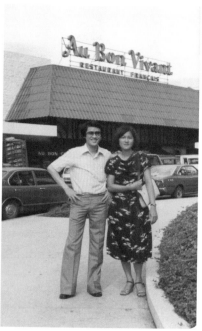

(clockwise from upper left): Nhi on horseback in Vinh Long,
Vietnam; dining out in the Phillipines with her brother Casey, who
came to visit from Hong Kong; arriving in New York

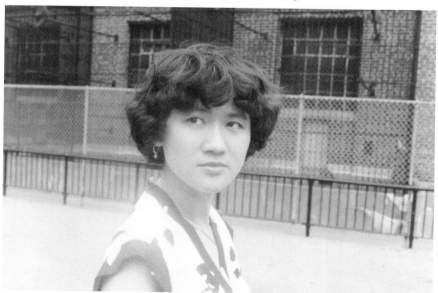

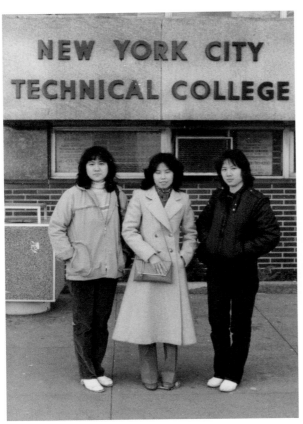

(above):
Nhi, on the left,
with two college
friends in Brooklyn,
New York

(below):
Nhi, on the right,
at an Amerasian
wedding in the
Bronx, New York

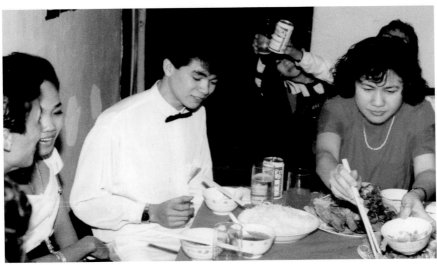

(above):
Nhi at an Amerasian party in the Bronx, New York

(below):
With ASHS colleagues, from left, Alma Warner,
Katie Kelly, Nhi, and Sheila Evans Tranumn

Back to Vietnam
(above): Nhi, left, with Ly Binh
(below): Nhi, left, with Phuong

(above): Nhi, on a boat in Vietnam
(below): Nhi, left, and her cousin Truong My Ngan, right
and her uncle Truong Tho Hoai, who aided many relatives
in leaving the country

(above): Nhi, vacationing in Florida
(below): Nhi, center, returning to the Sak Woi Club in Saigon,
with her husband Jimmy, left, and her niece's son Jun (right)

Chapter 9
Cholon

1. Nanjing

I returned to Vietnam in stages.

The New York school system is often in turmoil. A new mayor comes in and appoints a new chancellor who has some bright ideas on how to shake things up so he or she can put a stamp on education.

This occurred in a big way when the newly elected Mayor Bloomberg, who was so rich he didn't need campaign donations to fund his run, in 2002 duly appointed a fellow millionaire, super lawyer Joel Klein, causing something of an outcry from the public as Klein had no previous background in education. True to form for new chancellors, one way Klein left his mark was by closing schools and shuffling around students and teachers. Bill Gates, whom Klein was pairing with here, had been promoting the idea that students did better in smaller settings and, so, large high school after high school was shut and reopened as three or more smaller schools, the number usually depending on the number of floors. Seward Park: four floors, four mini-schools. (I might mention that Gates later summarily dropped the small high school idea, which he said had failed. And, remember, there was no educational research to support this change in the first place, it was rather something this influential billionaire liked and could put money behind.)

Even more drastically, although this was a little in the future, Klein shut down the whole branch of the Board of Education with which I was affiliated, Auxiliary Services. This unit included over 90 schools, both rooms in high schools and in off sites, such as St. Rita's, teaching G.E.D. classes. Klein was dismissive of the high school equivalency degree, famously saying that even when a student graduated with a G.E.D., it wasn't added in as part of the overall graduation rate statistics and, in that sense, didn't count. Auxiliary Services was shut down and I lost my job.

I might put in that, notwithstanding my near-20-years of teaching GED to high school students at that point, in which time I had racked up nothing but satisfactory and highly satisfactory ratings, when my program closed, I was told I was no longer qualified to teach at a high school be-cause my Common Branch license, earned decades ago, was for elementary school. Hence, absurdly I thought, in June I completed 18 years of high school teaching at Tenzer High School and, next September, I stood in front of a kindergarten class at PS 160.

Let me put in a final side note. Although there were some problems of adjustment, in my 9 years at 160, I ended up working under the able, nurturing guidance of principal Ms. Russo, such notable APs as Ms. Anderson, Mr. Gullo and Ms. Hamdan and such extraordinary and outstanding teachers, paras, and parent coordinators, including Mary Chu, Jessica Chiu (my wonder woman who helped me over so many difficulties), Tiffany Chung, Vicky Chiu, Winnie Tan, Kitty Tang, Mr. Lauro, Ms. Lantigua, Ms. Stroming, Ms. Gargano, Mr. Molter, Mr. Roberson, Jimmy Yu, Sara Zhang, C. Kei Xu, Lina Medina, Ms. Altobello, Christine Ryan, Nicole Cino, Arlene Russo, Miriam Markes, Lisa Mui, Noel Chiu, Ms. Bogan, Cindy Chan, Ms. Wells, Ms. Fraire and Vivian Lo.

I also worked wonderfully with Ms. Ryan, Ms. Monte, Ms. Romeo, Ms.Sparacio, Ms. Drossos, Teresa Ly, Ms. Penello, Ms. Papeo, Ms. Simone. Ms. Papaderos, Ms. Draxdorf, Ms. Dourakis, Ms. Crowley, Ms. Caruso, Ms. Jaffe, Ms. Tandy, Mr. Browder, Candy, May Huang, Pamela Wang, Ms. Hsu, Ms. Cullen, Ms. Tartaglioni, Cintia Mendez, Yan-Yan, Ms. Molfetta, Ms. Fox, Ms. Edwards, Ms. Ulon, Ms. Villa, Ms. Ennab, and Ms. Mulligan, among others.

I know it is a lot of names but we have been working all these years. And I don't want to forget our secretaries: Frances Cullen, Elizabeth Rich, Anita Rochford, and Michelle Amass, other teachers who have been so supportive of me and the students: Ms. Feola, Karen Zhang, Ms. Emery, Ms. Palazzo, Ms. Hayes, Ms. Lamberti, Ting-Ting Chen, Mr. DeRosa, Ms. Attina, Ms. Abbate, Ms. Shapiro, Ms. Koumousidis; our AIS staff: Ms. Connolly, Ms. DiMatteo, Ms. McMullen, and Ms. O'Leary.

I know I am leaving people out, so forgive me, but lastly, I have to recall the fine educators, counselors, therapists and paras: Carol Chen, Ms. Ward, Ms. Utkina, Erin Lew, Ms. Mach, Ms. Schreier, Dr. So, Ms. Leung, Ming Lee, Eric Zhong, David Ji, Ms. Maloney, Ms. Monfil, Ms. Nugent, Ms. Diego, and fellow tai chi fanatic, Wo Fen Ma. To you, this

is an endless unrolling of names, but to me, each person is a deeply committed educator and friend.

To my main point, with the topsy-turvy nature of school life, with not only the federal government, which told us to teach a common core curriculum, but the state and city government constantly imposing new standards, asking us to teach in different ways, and moving us around on the educational checkerboard, it's no exaggeration to say that we teachers had to live defensively. You had to watch out for and prepare as much as possible for the next wave.

This, and not so much my love of learning, had driven me (by that time) to get three master's degrees, which translated into three additional teaching licenses. I was aware of one of the new configurations of the system, which was this. When I started, if your school or position was eliminated, the Board would assign you to a new school, no questions asked. However, the mayor had pushed through a new contract by which you had to interview for a new position if you lost your last one, even though you lost your last placement due to something such as your school had been shut down or your position was no longer funded. Your hiring was at the principal's discretion. If you didn't find anything, you weren't fired, of course — we had union protection — but became a sub, a hellish job, as you moved from school to school, class to class, never knowing where you'd be assigned the next day.

I tried to prepare for any eventuality by supplementing my original Common Branch license with a bilingual one. That way, if I were laid off and couldn't find a job with my first certificate, I could look for a bilingual position; and, later, with another degree, an ESL one, and later still, with my special ed degree, I ended up with four options.

Even so, when Klein came to power, it struck fear in the Chinese bilingual teacher community — I was teaching under my bilingual license at the time — because Klein was an English-only type, who had more than once bad-mouthed bilingual education. The rumor, and it turned out to be nothing more than that, was that he was going to do away with bilingual education and, ipso facto, bilingual teachers.

Perhaps, it shouldn't have worried me as I could fall back on my other licenses, after all; but I felt antsy. And so I was interested to chance upon, when paging through the *World Journal,* an ad about getting a degree in teaching Mandarin as a foreign language at the high school level. The catch was that the summer courses for the degree were offered in Nanjing University in China. For one month's classes,

the fee was $200, and this included accommodations in a brand-new hotel on campus along with coupons for lunch, breakfast and dinner at the college's cafeteria. Moreover, every weekend the school would schedule trips to places of interest such Hangzhou and Shanghai.

(One of these trips was to Yellow Mountain [Huang Shan]. This peak is very famous and everyone who goes to China sees this super, super high mountain. To get to the top, you can either climb up or take a cable car. When I went with the school later, we walked down, passing a lot of hardy, middle-aged men, going uphill, carrying on their backs, sodas, snacks and other things to sell to tourists. At the top was a large, flat land where a lot of Europeans put up tents and stayed overnight so they could take pictures of the sun climbing over the horizon at dawn. People were carrying up snacks to peddle to them. As I've said, for the Chinese, making a living is often hard.)

Of course, to go to Nanjing, you had to pay your own plane fare but otherwise this is a very cheap price. These classes were only for Americans. There were only 30 places open and priority would be given to those who were already working in the school system.

I'm not sure if I really would have considered going except that a person working in my school: a secretary, Jennifer, was also interested in this, and my friend Patty, a bilingual teacher in Chinatown, acted as a spearhead. She strongly wanted to go and as strongly wanted friends to accompany her. I had met Patty when I was going to school at Seton Hall University. Patty recruited me, and I recruited Jennifer, who didn't want to become a public school teacher, but she had set her sights on teaching at a private, Chinese school on the weekends in Chinatown. She needed education credits to get a position. So we signed up. A funny thing happened. A few weeks before we left New York, we got a list of all the registered students. I looked down the list and saw the name of Tian. He was a para at Tenzer, my school at the time, who would soon become a teacher. I didn't know he had signed up for this course and, soon enough, he contacted me. Later, we worked together in Nanjing.

So it was that in July 2007, the three of us set sail, speaking metaphorically, for Nanjing. We flew to Shanghai, then took a train to the school.

It was in a beautiful setting. I lived on top floor in the university hotel and could look out my window at Xuanwuhu Lake Park, a large green space laid out around a great pond. The lake has five small islands, which are linked to the land by bridges, and it was filled with weeping willows, gingkos and floating lotuses. One island has a small

shrine to the lake god. In the distance, snaking through the park is a remnant of Nanjing's ancient wall.

Every morning, early, you could see groups of city residents exercising and playing tai chi: fan, sword, everything. I think one reason they came early is because, as an informational brochure from the school explained, the park "is located in a very scenic spot with very fresh air and admission to the park is free until 8 am." Thrifty Chinese. The park was closed at night (By the way, another peculiarity of the Chinese system is noted in this same brochure when it is talking about transportation to Nanjing downtown. "The bus fare will be one yuan (without air conditioning on the bus) or 2 yuan (with ac on the bus)."

The semester was four weeks. Classes were every weekday, from 9 to 12am, with a one hour break for lunch, and then more classes from 1 to 5. In my first semester I took Classical Chinese Literature, Modern Chinese, Chinese characters and Calligraphy and Advanced Chinese.

After class, we would usually eat in the building and then go upstairs and prepare for the next day's lessons. The building was compact. The cafeteria and offices were on the lower floors; classrooms in the middle, and hotel on the top.

The 49 students attending the summer term were generally middle-aged, in their forties and fifties. Almost all had been born in China but had already lived in the U.S. 10, 15, or 20 years. The majority were teaching at public schools, many of them in New York City or Long Island, but there was a sprinkling of teachers from private institutions, such as the Whitby School in Connecticut, and from colleges, such as one person from Tennessee's Lee University.

My Chinese is okay but it was inferior to that of most of the other attenders. I completed middle school Chinese before switching to an English school in Vietnam while most of my fellow students, including Tian, had attended some college in China before moving to the U.S.

That's why Jennifer and I were constantly shuttling between floors so we could go to Tian's room to have him check over our Chinese grammar. Moreover, we sometimes needed further coaching on the Chinese classics as we didn't grasp some of the concepts the teachers were throwing out. Remember, we were not getting the interactive teaching one might find in an American university. This was traditional Chinese pedagogy. The teacher lectured and wrote on the board and we took notes. Open book, teacher talks without interruption for an hour or so, close book, class over. No questions. The classroom didn't

have a smart board, but we did have a computer on every desk to help us with note taking.

It was hard work, almost daunting, but with Tian as our resource person, Jen and I — Patty had been an exceptional scholar in Hong Kong and didn't need extra help — got along well. And we also played hard. We took all the weekend excursions, such as the trip to the magnificent Yellow Mountain (Huang Shan), and some days we didn't eat in the school but went out into the neighborhood.

It's a good experience to see China at night: the neon, the people crowding the sidewalks, and, very important, the food stalls where we bought such delicacies as gizzards; fried squid on a stick; meatballs on a stick; bad-smelling, good-tasting tofu, and chicken legs on a stick.

In New York, our Chinese friends warned us about the things to avoid. There were plenty of stories in the Chinese papers about, for example, a man who didn't get a job or got depressed and then went on a rampage. Not long ago I saw on YouTube a sequence taken from Chinese street surveillance camera. You see a man buying a chopper at a sidewalk stand. He pulls it from the plastic bag and goes down the street slashing and stabbing people. There is a lot of crazy stuff in China. Still, where we walked there were police everywhere and we always felt safe.

We were also cautioned about the toilets and it was true that even in five-star restaurants, they only had squat toilets, a hole in the floor with a foot pedal to push for flushing. The problem was they often smelled real bad so that if you didn't have an upset stomach going in, you had one going out.

But these are all small things, side issues, really. The big thing was that with the colors, the language, the ideograms on every wall and store, the street carts, the smells, even the bad ones, the camaraderie with my fellow students, the comradeship with the staff, for the first time in a long time I felt I was halfway back into a world where I belonged and which understood me. Halfway, only halfway, because the peculiar, complex network of interweaving Vietnamese and Chinese culture of my homeland could not be created in this setting even if I visited a Vietnamese restaurant. I had already seen, in going to L.A., that it could not be replicated in Westminster, known as Little Saigon, a town just south of the bigger city, which was made up mainly of Vietnamese refugees and their descendants.

The experience brought me closer to myself and yet farther from myself. That's a paradox but one I call a sensible paradox. Closer be-

cause I was immersed in a fuller, more thoroughly Chinese world than I found in Flushing or 8th Avenue, Brooklyn. Farther, because something was missing, the Vietnamese inflection.

I call it a sensible paradox because that is one that will right itself as long as you are willing to pursue its hidden message.

2. To Go Back

So why, up till then, did I never think of returning to Vietnam? Let me first say that many of us, many of my cohort of refugees, never went back. My friend Rainbow, who impressed all my schoolgirl friends and me when she married the son of a high-ranking military officer, is one example. When I talked to her about why she didn't ever revisit Vietnam, she said that her whole family left. "23 came out," going by way of Malaysia. She didn't sneak out. Her family was allowed to leave once they had surrendered what they owned to the state. Rainbow said, "The Communists got everything; we got nothing. The government said, 'Give me all your property and you can leave. How many houses? How many motorcycles? Plus the gold.'"

She went on, "We had a coconut oil factory, a grocery store, a liquor store, selling the top merchandise, Johnny Walker. So the whole family, almost the whole family left: father, stepmother, children."

The only one who couldn't leave, because he had become a captain in the South Vietnamese Army, was her husband, who was placed in a prison/work camp for 10 years. Rainbow remarried in the U.S. and had two wonderful children: one, the girl, now in the F.B.I., and the boy, a public school teacher. Still, her family's loss of all they had accumulated and her personal loss of her husband made her lose any allegiance she ever had to her homeland, and though her brother went back for a visit, she could never bring herself to do so.

My friend Catherine's husband also refused to ever return to the country of his birth though Catherine herself returned after three decades. They also came out on a legitimate boat. As Catherine explained, the Communists said, "You pay, give us your house, store, and you can go down." However, the boat they took was a doomed one. They were heading for Malaysia, but there were difficulties. For one, the ship was overloaded. It was a small vessel but, Catherine said, "It was crammed with 358 people because the Vietnamese police like money. They kept selling more tickets. Then, once we were at sea, the two captains began fighting,

really fighting. One took an ax, another a knife. So the ship kept turning around in the sea as they argued about what direction to take.

"At that point we were attacked by pirates. They bumped into our boat and came aboard. They were in big hurry. They just grab everything and go. But when their boat hit us they left a small hole in the hull, and water was slowly leaking in. A second group of pirates came and grabbed more. You know the pirates always monitored the radio and know when a boat from Vietnam came out. They pretended to be fishing boats, and they waited around for you to pass.

"Then came the worst group of pirates. They wanted to take anything that was left. They told us to take off all our clothes. We could only keep one shirt and one pants. The rest they stole. They also checked my mouth and everyone's mouth. They ripped out gold teeth. They shoved down and raped the women. Even one mother and daughter were raped. I escaped because I was holding two small, crying children in my arms. The kids were screaming because the water was up to my waist. Perhaps I was spared also because I was one of the few that could bargain with the raiders because Thailand pirates mostly speak my first language, Chaozhou.

"One pirate had taken all my remaining jewelry and then he grabbed my address book from my pocket. I needed that book because in it was the address of my younger brother in the U.S. I said to the pirate, 'Please, leave me that book.' He was staring at it. I knew he couldn't read so he didn't know what he was holding. 'What's this?' he asked. 'It's got my brother's address. Please, leave it to me,' I replied. He handed it back over. I guess he figured everyone on my boat was going to die anyway.

"I was near the side of the boat and — I can never explain why — I saw the pirates were kidnapping my father. They had thrown him in the water with a life preserver so as to tow him behind their boat. I kept yelling, begging the pirates. 'This is my father. Please, leave him with me.' Again, I can't explain but they let him go and he swam back to our boat.

"The pirates left and our boat was sinking. Everyone was screaming and crying. The only one thinking was my husband Johnny.

"We were in the South China Sea, way off the coast of Malaysia. A couple of miles distant my husband could see an American oil drilling platform. He dove in and swam to it. Now I was even more scared because I could see sharks in the water. He made it to the platform, which had a ladder hanging down. As luck would have it, though almost ev-

eryone on the site was an American they had one person who spoke Mandarin. Even better, since my husband had very limited Mandarin, it turned out the cook spoke Chaozhou and they could communicate.

"My husband asked him to rescue us. He said we had a lot of children, seniors. They were willing to help and got us out on a boat and pulled us all up to the platform. Only one poor dog died on the boat.

"I was worried about my husband. He was coughing blood. I think it was because the water he was swimming through was soaked with gasoline. He did recover and now he is still kicking at 70.

"The Americans allowed us to take a shower and they called Singapore about taking us in. That country said there were too many of us, but then Malaysia agreed to host us.

"And another miraculous thing happened. Through the Mandarin-speaking worker, who also spoke English. I could communicate with one U.S. gentleman on the boat, who said, 'I am flying to America today.' I told him I will write to my brother and, maybe, he could send it for me when he got there. He agreed to do it and two weeks after we landed in Malaysia, my brother contacted us.

"The Red Cross helped us and we stayed in Malaysia for fourteen months. There were U.N. forces there. I cooked for them. I liked it if I can help them.

"So, 38 years later, some friends were going on a tour of Vietnam and asked me to come along. I said I would. I asked my husband to accompany me. He said he was still hurt by what happened. All his dad had built up, gone. His father was a Chinese doctor who had a herb store, a garden for rare plants, gone. Moreover, my husband said, there's nobody left in Vietnam. They're all here already.

"I said, 'Well, Johnny, do you want to go back?'

"'No, sorry'."

3. Cholon

Unlike the friends I mentioned, I always wanted to go back to Vietnam, no matter what happened to me. Who doesn't want to go back to their hometown? You want to see the places you grew up, look up old friends, eat the good food. You can never get real Vietnamese food in the U.S.

Of course, you have to have money to return. You can't go back without some cash but once I had enough to pay for travel, and my kids were grown, I still held back.

Before he died, my father borrowed a lot of money to expand his business, and he was never able to pay it back. Someone told me that if you owe money, they put your name in a report, and when you return to the country, they arrest you at the airport. My father had already borrowed funds in his own name and, when he needed even more, he put the loans in my name. Those monies were never paid back. I imagined the police clapping me in jail the minute I stepped off the plane.

My one contact in Vietnam over all these years was Ly Binh. Every Christmas we would exchange cards; she would give me the news and tell me her son needed money to go to college or her husband needed capital to start a business. I would write back and tell her how I was doing, enclosing $100.

The way I met Ly Binh was this: Her father was an officer at a Vietnamese bank. As he was fluent in both Chinese and Vietnamese, he was a great asset to Chinese businessmen like my father, who had trouble reading and writing Vietnamese and needed assistance filling out the paperwork necessary to obtain building permits and loans. Her father helped my father on numerous occasions and, in order to show his appreciation, dad hired Ly Binh to work in our warehouse. That was the place where all the factory supplies, including pipes, machine parts and oil, were stored. Her job was to check in and out the materials.

This is a little off track, but I want to mention that it was Ly Binh who introduced me to Rainbow, who was her brother's classmate. Because of this, I was able to attend Rainbow's marriage to an army officer, which was held in a restaurant in Thu Duc, the Saigon suburb where our factory was located. This was a gala affair, with more than 100 tables for guests, including army officers, women in fancy gowns and assorted big shots. I was so impressed by the fact that they were using a video camera, very advanced for 1974. In very traditional Chinese culture, as I said, the bride stays in the room during the party, but Rainbow's family was modernized. In her party, the bride and groom went from table to table for a "bottoms up" with the guests. After the toast, guests would slip the bride a "red envelope."

To get back to my account, I wrote Ly Binh and mentioned my fears about returning to Vietnam. She immediately wrote me back a long letter, calling me crazy. She said, as a banker's daughter, she knew about these issues. Thirty years had passed since my father took those loans, and every banker around in those days had either died or left the country. She reassured me with strong words, telling me there was "no

such thing" as people being arrested for unpaid loans that had been made before the Communist era. If that was the only thing stopping me, she said, I really should come back and see her.

How could I resist?

It's not as if I had no relatives in Vietnam. The black sheep of the family still lived there. No, that's something of an exaggeration. I need to explain why, among all my family, only one person didn't leave Vietnam. Binh, my older sister, 10 years older, had six kids before the war ended. In birth order, they were Huong, Phuong, Minh, Hoa, Mang and Vuong. (By request, I am not using the U.S. children's real names.)

After I left, they attempted an overland escape. Huong, Minh and Hoa, walked overland, ending up in Phanat Nikhom refugee camp in Thailand where they stayed from February 1987 till March 1988. From there, all three ended up adopted by a couple on Long Island. Mang and Vuong walked out with a different guide and made it to Thailand where they stayed for about a year in another camp until Huong, upon reaching legal age, was able to sponsor them to come to the U.S. Phuong and my sister Binh also tried to walk out but they were caught and imprisoned. They were released shortly thereafter, but decided to not chance another attempt.

Back in the U.S., once Huong was of legal age, she also tried to sponsor her mother and sister, but it was much more time-consuming to get people from Vietnam than from a refugee camp. During the long wait, Phuong had married while continuing to take care of her mother. Finally, by 1991, all the paperwork was completed and their immigration was approved. The U.S. children got together and raised the money for plane tickets so the two could fly over. (By the way, none of Binh's children lived in New York City, and, spending my time raising kids, going to school and working full time, I was only vaguely aware all this was taking place.)

Here's the dramatic denouncement. Phuong took her mother to the plane but, at the last minute, refused to go with her because she decided she couldn't leave her husband behind, which she would have to do. Americans would probably sympathize with her choice, but for traditional Chinese, family, the blood-tie family, is all-important, so Phuong's staying in Vietnam created bad feelings on my sister's side of the family, although of this I was only peripherally aware. It was also in the margins of my consciousness that I was going back not only as a returnee but as a sort of olive branch.

So, to get back to my trip, with my suspicions allayed by Ly Binh's letter and, having been accustomed to the 16-hour flight on my visits to Nanjing, I returned to Ho Chi Minh City. And the first thing that hit me was that, just like the name of the city, which had been Saigon in my youth, the street names were all new. What had been (to Anglicize the words) Rice Street or Dragon Street was now Heroic Lieutenant Phan or Heroic Nurse Bui streets. And everything else was also changed. My house was now a bank building and, more surprising, the land next to our home, which had been a two-acre South Vietnamese military camp, was now a bustling neighborhood of two and three-story houses.

Vietnamese homes are not like those anywhere else. They are so skinny. The ones back in the alleys, such as my niece's, are multi-storied but so lacking in space, you had to go from floor to floor on steep, ladder-like stairs, something like those in ship's holds.

I was also immediately struck by what looked like the day-to-day people's unexpected tolerance. By this time, I was not worried about how people would treat me — the debt had been forgiven or forgotten — but I did still worry about the reception of my husband, an American. I wondered if they would blame him for being from a country that prolonged and extended the Vietnam War. Maybe a stranger would bother him as we walked around.

No worries. All you see on the street are young people, and, as the Vietnamese newspaper mentioned, they either don't care or don't know much about the war, and they liked Americans to come here. People who went through the war were either dead or stayed home. Ah Phuong's children, now teenagers, had been born after the war.

To say one more thing about the changes in exteriors, I later went back to visit the city of our family factory in Thu Duc, which had now become a government compound. The whole neighborhood went through an upgrade. When I had worked there, back behind the factory fences was nothing but grass and bamboo huts. Now the area was crowded with big, luxury buildings. I peeked in one and saw a lobby with beautiful white linoleum, inlaid with yellow dragons. I found out that a lot of Chinese who had escaped to Taiwan during the war were now moving back to this area, where they had grown up, now that they had retired and had money. Moreover, a lot of those who fled to America, those whose families had scattered in the emigration, while they didn't want to resettle again, would purchase a nice, three- or four-story house in Thu Duc. In the winter, they would come from all

over the U.S. and Canada and have a family gathering in the house, staying a month or so, usually to celebrate the New Year's.

I don't know if an airport can be considered a weather vane, pointing to a society's essence, but on first embarking at Tan Son Nhat Airport in Ho Chi Minh City airport, my immediate impression was of the total omnipresence of street life. Stepping out of the plane itself into the enclosed, connecting bridge to the arrivals area, there is a sort of crevice where you step from the plane and in which, for just a touch, you first feel the warmth and usually rain-smeared air of my country. You go through arrivals, collect your luggage and outside into the cacophony of those exiting and awaiting arrivals. This is not like JFK with various spread-out terminals. Everyone comes and goes through one door, so coming out means entering into a flood of people, standing among trunks and ferried packages, squatting to spoon up soup, greeting and yelling.

But what I meant by omnipresence is really how the airport, which I had never visited before, was enmeshed in the urban network. Unlike LAX, JFK and other airports with which I am acquainted, all of which are blocked off by a lot of open space from the surrounding community, at Tan Son Nhat, you get in a taxi, cruise about a half block, pass through a toll gate and you are downtown.

From there, it was still an hour's drive across the city to our hotel in Cholon (Chinatown). We had arrived late at night and as we whizzed through the relatively deserted streets, and as my niece Phuong caught me up on her family's fortunes, I couldn't help side-glancing at the few still open clubs and cafes. As in China, neon and other light effects made for enticing pictures. In a café whose entrance was set back, a thin lace of water fell before the front window, landing in a rockery. The waterfall seemed to change and turn under the play of alternating blues and greens that rippled from unseen spotlights. Beautiful light displays also wheeled through many of the bustling, open-air eateries. Given the year-long balmy, oppressively balmy weather, many restaurants had roofs but no walls, thus allowing any breeze to enter freely. We passed one that had entwined green, Christmas lights around every pillar and roof brace, making the establishment a lovely, electrified arbor.

I don't intend to describe my entire visit, but I want to just mention a few more things that I noticed on my first night and morning in town. Our hotel was not one of those multi-star behemoths, such as the 30-floor Lido Hotel we stayed in when we visited Guangzhou. The Cholon hotel was a family business, five floors with four rooms per floor.

Our place on the second floor had a large living room with an Lshaped couch and glass coffee table on which sat a teapot and complimentary loose tea. The bedroom to the left contained one large bed and, at its foot, a smaller one. To the right was a compact bathroom with a glassed-in shower stall.

For us, the luxuries were the strong air conditioning, which was heavenly to meet when we came back from a boiling day outside, and the tiny balcony from which, low as we were, we could watch the many goings-on in the street and the stores across the way. For instance, I remember I was looking out when there was a sudden shower. All the motor-bikers pulled over to don their raincoats and ponchos. I think the Vietnamese have a specially made poncho. Frequently when there were two riders and it started to rain, the driver would spread the large tail of his garment so it completely covered her or him and the rider from the downpour.

That first morning, Phuong and her daughters said they would take us to eat at a local market. We went out of the hotel and walked toward the broad avenue we had to cross. A hurricane of motorbikes, scooters, motorcycles and the occasional car (which stood out in the flow like a boulder putting its head above a stream) was ripping across the intersection. Ahead of us, as we walked to the corner, we saw people plunge in, little Moses around whom the motor sea parted. They were walking in moving circles of safety, with the metal machines speeding past but never touching them. If only there were traffic lights, but there were so few of them, they were as frequent as the kind of far-between road signs one finds on disused, deserted highways

When we came to the corner, Ah Poi took me by the elbow to guide me, as if I were a blind woman, into the slipstream, but, even then, walking slowly at her arm, I kept flinching as the motorbikes whizzed past. It was they that adjusted to us, observing our progress from a distance and catering to our movement across the street. Still, that was an intellectual concept, something I knew in my head, while physically, emotionally, my thought was charged with the specter of a driver losing control and striking me. It would take a while, and it wouldn't be that year, till I could cross unassisted. And, let me say, in a compliment to the drivers, in my six years visiting, I never saw a crossing pedestrian clipped.

So Ah Phuong brought us to the street market for our first breakfast. As you may know, these markets are, in a sense, transient. About 5 am, people open their house fronts, which are closed with steel

shutters, not doors, and, if they have a restaurant, trundle out the tables, chairs, awnings, food cart (which serves as their kitchen) and awnings for the morning's business. Meanwhile, down the middle of the street, which is now divided into two channels, four sets of counters are pulled into place, and items for sale, whether veggies, meats, fish, children's clothes, notions or T shirts, are laid out. The grocery counters are one section, covering maybe an eighth block from the three entrances — the stands are on two long blocks that meet in a T formation — and the rest is grocery. (By the way, Americans might be shocked by the fact that cuts of meat and fish, unwrapped, are laid directly on the wooden tables so people can pick them up for examination as they consider purchasing.) The most cramped section, near the entrance, has the many, tiny clothing or fabric stalls. Jeans, for instance, are piled on the shelves and front counter. To take her place, the sales lady — with very few exceptions those selling in the market are women — has to climb over the counter and crouch on the jeans which are piled under her.

By 5:30, things are up and running and people are crowding in for their day's shopping. By 11 or noon, everything folds back up till tomorrow. The stands, food carts, chairs, tables and things for sale are taken back indoors, and the street is free for bike and auto traffic.

I said "awnings" earlier but this doesn't mean prefabricated coverings, but rather a collection of tarps, drop cloths and sheets, knotted together or overlaid and thrown up to block the day's increasingly hot sunlight. On this note, let me say that eventually we became friends with the owner of a vegetarian restaurant, Ah Kum, and would eat congee at her place most mornings. Next door, there was a bigger restaurant, serving noodle dishes. They didn't put up their sun covers till it got really hot. Then the waitress would stand on a chair and roll out their awning, which was flowered like a bedspread, tying it with cords to the already outspread covers of the meat stands across the way.

I might add that Ah Kum herself was not a strict vegetarian, but she had opened this type of store to fulfill a vow to the Buddha. Indoors it held one and a half tables. I count one as half because, due to the small size of the space, one table had to be shoved against the wall. Right in front was her food cart, on which she prepared simple vegetable dishes. On the other side, on the ground, was a big stewing pot of congee. It sat atop a brick cylinder filled with charcoal which cooked and kept the gruel piping hot.

Sitting there most mornings I got to meet a large swath of people who came to eat, mainly Buddhists on a strict all-vegetable diet. I saw the market women's camaraderie and the informality of customer relations. For instance, once Ah Kum went upstairs to look after her grandson. A customer appeared so one of the diners got up from her meal, served the congee, which she packaged to go and took the money. When Ah Kum came back downstairs, she passed her the money.

Last point. I learned the grandson would be brought to Ah Kum's house quite early because her daughter had to line up in front of a nearby shopping center to get picked up by the company bus at 6 am. They would be driven out to the countryside to work as office people in a large textile factory that employed 3,000 Vietnamese workers. The many Chinese picked up in Cholon were not hired due to prejudice against Vietnamese. The factories were owned by Taiwanese who made dresses for U.S. companies. The designs were programmed in Hong Kong. That meant an office staff had to be hired who not only spoke Vietnamese but Cantonese (for HK) and Mandarin (for Taiwan), and most Vietnamese didn't qualify.

To return to my first morning, as I timidly followed Ah Phong across the street and then into the bustling outdoor market, I felt overwhelmed with the sights, smells and noises as if I had been violently wrenched back to the only city I would ever fully know. Feelings were flooding me, just flooding me.

Now Ah Phuong is very smart. She had to live with (what the whole family considered) a bad decision of remaining behind in Vietnam, but as I was seeing, she had raised three good kids and survived in a little, not much, comfort.

Immediately upon meeting her, as we taxied from the airport, she began telling me her tale of woe. (I guess it's universal that poor relations will complain about all their bad breaks to the better off ones in the family. None of which makes what they say untrue.)

As I said, I was a bit outside the family loop since Phuong's mother (my sister) and siblings lived in upstate New York, so I was hearing all this for the first time. Phuong and her husband, Ah Guy, had set up a business when the children were still toddlers, selling and assembling toys to be sold in the interior. They used their downstairs as a workshop. They prospered for a while and then there was a flood in the countryside, which blocked all the roads so nothing could get delivered, nothing sold, much was damaged, and they ended up losing the business.

However, all that was years ago, their more recent troubles involved our relations. I won't try to disentangle who's to blame as it is probably no one. As her kids got older, Phuong determined they would definitely have a better life in the U.S, so, by mail, she talked one sister into sponsoring her. People, including her, and even Americans, don't realize how tricky immigration is. In fact, few know that in the 1990s, for instance, Vietnamese immigration was frozen, halted, for more than five years. In any case, as things progressed and as Phuong understood it, there came a point when, in her phrase, "There was only one more paper to run" before she and her family could embark for the U.S. They sold their house (at a loss) and moved into a small, overcrowded apartment It was only for temporary, she thought, and, after all, they would be leaving behind any furniture they hadn't already given away. But that paper didn't go through. My guess is that Phuong had underestimated the difficulties. Then to add to the problems. Immigration was frozen.

To jump ahead for a moment, it became my goal, later accomplished, to collect money from different relatives to buy Phuong a house since it looked like Cholon was going to be pretty permanent for her.

Once, she realized she was stuck in Vietnam, and with her business gone, she and her husband took up careers. Guy worked as a home renovator for a Chinese contractor; Phuong divided her time between teaching Chinese one or two days a week at a Vietnamese language primary school and taking private clients whom she tutored in English. These one-on-one lessons were given to children of parents who would soon be moving to the U.S. and wanted their kids to get a head-start with the language.

All Phuong's children knew some English; the older girls were both very studious. The older, Ah Poi, thin and willowy in build, a little shy in personality, already had a small command of English. She started college the next year after we visited, but quit because it was such a long motorcycle drive to the school and, once, on the way there, she was in an accident, which spooked her. So, she took a job in a travel agency, eventually rising to manager, while continuing her studies at night school.

The youngest daughter was Ah Ling: spunky, outgoing, tomboyish, and interested in the latest Japanese fashion. She also studied hard, after mastering English, going on to Japanese. She took a job in the same travel agency where her sister worked. I'm jumping ahead here,

but I should say that, being so adventurous, Ling worked a year in Manila at an online gambling firm. As we learned such gambling is illegal in China, but many Mainland Chinese use offshore sites, particularly those in the Philippines, to practice this vice. Consequently, the company needed to hire many Chinese speakers to deal with the customers. When Ling came back, she rejoined the travel agency.

Their brother, Ah Jun, was a less diligent student and, after high school, took a job working on a truck. He is a handsome fellow with many friends and activities, so, as I gauge it, he is just not that attracted to the U.S. and the English language, though, given his sisters, he does have a solid rudimentary knowledge of the American tongue.

These were the people who immersed us in their life and showed us the reborn city. It was no longer the place I had known, but, often, around the edges as it were, I felt a deep resonance with lost memories.

I talked about being "flooded with feeling" in the market. What did I mean? I think memories need common ground. Is that the right way to put it? You remember more perfectly if you are on or near the site where those memories were created. So, in a way, going back to Vietnam was as important for what it prompted me to remember as for what I could see. When, for instance, I ate at a certain outdoor market, I was distracted from the conversation by a stream of memories connected to that place, that corner, which I believe would never have come back to me if I hadn't sat in that chair. Talking to Phuong also reminded me of so many forgotten incidents. These things, brought up when people speak to me, I call third person memories. It was significant to renew my acquaintance with these forgotten times, cause, I think to be whole, you have to get back your memories

I guess I can end this book by noting three moments when I felt that flooding with a multi-leveled, multi-temporal feeling.

The first time was when, perhaps on our first or second day, Phuong took us to eat outdoors. The inside restaurant was a cubbyhole with only three or four tables, but its outdoor tables stretched in three lines down a half block, running in three columns. One group went along the curb and was separated from the second by a fringe of plants and young palms in planters. Then came the broad sidewalk and, beyond that, at third row, running near the front of the office towers that made up the block's buildings. In the morning, the buildings' shadows combined with a not infrequent, light breeze made this a great place to eat breakfast noodles, enjoy a cool drink, chat and watch the motor-

bikes, ever-flowing in the street or stopped in an eddy. Some rolled past us to be tagged and parked in the restaurant's parking line.

The tables were low slung, rising to about knee level, made of the red plastic used for children's chairs. Every Chinese house in New York City has these molded, plastic kids chairs, ones which might be used by five-year-olds in American kindergartens but are occupied by adults in Chinese homes. Around the café tables were beach chairs with inclined backs — again a feature in American Chinese homes since they are cheaper than other furniture. In the restaurant, the seats had canvas slats of red and yellow, and proved comfortable enough.

Across the street were two coffee shops as well as various stores selling clothes and food. Also, as to commerce, as we sat eating, various peddlers passed: offering notions (displayed on wooden boards they slung with a cord around their neck), fruits (in the baskets of bicycles), and the ubiquitous state lottery tickets. Rising above or adjacent to the shops across the way were thin, four-story apartment houses. Right next to the café we patronized were three of these buildings, whose colors complemented; one yellow, one light green, one mauve. The outer two buildings had complete balconies for each residence whereas the middle one had balconies that only extended partway across like half smiles.

As in common in Vietnam, if nowhere else, meals and drinks were handled by separate establishments. So, after taking a table, if we wanted coffee, we didn't order it from the noodle shop that was serving our breakfast, but from one of the cafes across the thoroughfare. It was a busy street and, so it was with some agitation, at least during my first breakfast, that I watched the waitresses and waiters crossing from the coffee shop, tray held in one hand at head level, making a smooth dash across the street or returning, trays resting against their hips, through the constant traffic.

As I sat down, I saw dishes on the ground at the next table, and then remembered that this was how it was done. When you were finished, you put your plates on the pavement as a signal to the waiter to pick them up and hand over the check.

But it was when the traffic at the intersection was halted, that I suddenly felt a deeply connecting reminiscence. Everything had stopped for a funeral procession. A man walking in front carried a huge portrait of the deceased. Behind him was the open hearse, decorated on the sides with golden dragons. Sitting inside on both sides of the coffin were the pall bearers. Marching a little back was a band playing disconsolate

music. Right behind the hearse came the family members, dressed in rough, white cotton robes with white headbands holding back their hair and with white hoods falling down over their foreheads. This moment took me back to when I had my own place in such a procession at the time of my father's funeral, that and the memories that came with it.

The second igniting of memories came on a trip we made to the interior. Ah Kum and various market women who belonged to a Buddhist society had raised 1 billion Vietnamese dollars (about $20,000 U.S.) to buy a bridge for an impoverished rural community. The Buddhists believe that raising money to build bridges is one of the ways to do good deeds so as we may have a better life in the next world. One Sunday, they invited us to accompany them to the dedication ceremony. Ah Kum didn't explain much about the trip so I was surprised when, after a few hours traveling, we came into a small town and stopped at a wharf.

We got out and I learned that there were no large roads leading to the community where the bridge was constructed so we would have to arrive by boat. People traveled the area on motorcycles, and the bridge itself was only large enough to accommodate motorbike traffic.

I remember as we waited in the thick heat that I laughed when my naïve husband asked, pointing at a little structure, why the village people put incense sticks at a dog house. I laughed because of what he was referring to: a small house facsimile with offerings in front of it, which was not for animals but for ghosts. As is the custom, the conscientious Buddhists of the town, knowing that some people die lonely with no relatives near, leaving ghosts that wander homeless through the world, built these small structures that the ghosts could take as their homes, and which would prove to these lost spirits that people still respected them and made sacrifices to them.

I had little time to explain this as we were being shepherded onto a small flat motor-driven boat. Climbing aboard was not easy. Not only was the boat rocking but there were missing slats on the floor, through which you might dunk a leg in the river.

The river, more of a channel really, was hemmed in by overhanging bushes, vines and trees. The lucky ones in our group were able to squeeze into the covered front section of the boat, hunched around the engine, but most of us sat outside on the parallel benches that lined the gunwales, fanning ourselves in the steamy heat and dodging branches that poked at us from all sides. Occasionally the captain cut off the engine and let us glide along as a way to save gasoline.

The ceremony, which took place under a big canopy set up outside and supported by bamboo poles, was filled with a diverse crowd, including countryside people, village elders, young women in traditional costumes who acted as ushers, and our Buddhist society market women. In front was a phalanx of monks and Communist Party officials, who soon lined up and gave (mercifully short) speeches of appreciation.

Even under the canopy, the heat was scalding, and I noticed that a few from our group had hand-held electric fans, which they shared back and forth, but everyone else was working a traditional Chinese fan, each with their own personal rhythm and flourishes.

After the speeches, we went outside for the ribbon cutting. That was quick, with a smattering of applause and the first motorcycle roaring over the span. Then there was a lot of posing and picture taking as we slipped off behind a hut to pee.

Then we were back on to the boat, flooded with sweat, hunkering down to avoid the too lush vegetation. It was then I remembered going to a similar river bank with Ly Binh, and just simply felt the whole experience of being transplanted to a rural backwater to work in father's factory at Thu Duc, which was such a culture shock for a city girl.

My third moment of reminiscence, and this is predictable enough, came when we went to burn incense to my ancestors at a temple in Cholon. As is the custom in Chinese culture, if in no other, a person is buried in two places. The body or urn is in a cemetery, like the giant graveyards on the hills around Hong Kong. But a second place for the ancestors is kept nearer home. The cemetery may be a long distance away. For instance, my parents' graves — my mother's body had been washed ashore and reclaimed as I mentioned — were in a cemetery that was a few hours' drive away from the city. So, to make it easier for people to visit often, wooden spirit tablets with relatives' names are put up in a local temple. These are the ones Phuong took us to visit.

First, though, we had to go to "Ghost Street," which is where they sell different items: paper clothes, including shirts, pants, shoes, skirts, hats, and also other-worldly money, gold bricks made of folded paper, and all the objects and currencies that would be useful in the afterlife. From Ghost Street we went to the market to buy oranges, star fruit and a mango to offer. Phuong was so conscientious she even stopped at a café. Again I had to laugh when my husband asked if we had time to stop for coffee. The café was on a cul-de-sac that ended at the temple, and it was prepared with special mini-cups of espresso that were used as offerings.

Phuong told Jimmy that her grandfather (my father) had loved this kind of beverage and it would be satisfying for him to accept this sacrifice.

We went into the 1,000 Buddha temple to the second floor. In the first room, facing away from the stairway was an altar to Kwan Yin. In its center stood a large effigy of the gold-leafed, multi-limbed goddess. In front of her were seated, doll-size incarnations of the same goddess and, on either side, mid-length male gods. Set around these statues, hanging in the air were artificial lotuses that were bathed in a rotation of neon colors: blues, golds and pinks. Behind the figures, as a backing to the altar space, were potted, young, living stalks of bamboo, lit by Christmas lights wound around their lengths and making it seem as if the altar were part of a grove. In the next space, the spirit tablets were housed in a honeycomb of parallel walls. On each side of the narrow aisles were walls, on which, starting at waist level, were glass cases holding the name tablets. Each tablet was of red with gold letting. At the top, if this space was not empty, was a passport-sized photo of the deceased or, occasionally, of a couple. Below that, the ideograms supplied the family name and then gave some background, such as "father of" or "daughter of."

Where the tablets began was a ledge on which were displayed a few flower pots. To place offerings, you needed to pull out a little shelf on which to place them. Phuong showed us where my father and mother's tablets were located, and we began setting out food and drink. These included two "don tats" (custard squares), two apples, some dragon eye fruits, a mango, some kumquats, a small coffee and a few buns, ones specially sold for offerings to the dead, with slogans on them, such as "Good wish." After those offerings were set out, we crouched down and prepared bundles filled with appropriate clothing and money for each relative. Each was labeled with their Chinese name.

Setting this aside, we lit incense and kowtowed three times for each ancestor, placing three sticks of incense in a holder in front of each tablet. Then we continued through the temple, bowing and leaving three sticks at every god shrine, and finishing by going to each aisle and showing respect to each wall of tablets. Truthfully, there was so much smoke from our band and from other worshippers that I began choking and had to go out on the balcony to catch my breath.

After we finished with the incense, we went downstairs where they had a large furnace with a swinging door. A lay helper opened the door. We pitched in the bundles and watched the flames root around in them till they were consumed.

We climbed back upstairs and took down the fruit offerings. Some we gave to the lay helpers (cheap things) and the expensive fruit Phuong took home. The spirits had already gotten the good of it.

What struck me this time, what I took into my heart, were the black and white pictures of my mother and father that were affixed to their tablets. I had no pictures that survived my journey as one of the boat people. So it was the first time I had seen their faces for a long time. It left me swirling, not as one does in the water, but as one does with memories, dark and light, strong and weak.

I want to end here. There's a lot I left out: my kids, my husband, my tai chi club, but I always thought it would be a selfish act (and certainly not in harmony with our Chinese traditions) to write a memoir just about yourself. Other people's stories, those of the Ameriasians, of Flora, of Jack, of Catherine, of Ah Phuong, also belong here. Otherwise, you won't know that my story stands for and is part of others, that separate for a time, but are also really me.

This is my full circle. I always wanted to have — thinking of my zodiac sign — a happy snake life. The blind fortune teller told me a few months ago, when I consulted him about my daughter, that I would finally have that life. And, he said, that because I was born in a special month, my destiny was to help three generations.

I know I helped my father. After all, to work in the factory I had to learn to drive, something very few women did in Vietnam at that time. I helped my own generation, lending money, once I was established, to help my relatives. Not only did I help organize a fund to pay for Phuong's new house, but also (with the help of others) got the different families to contribute to our great uncle Hoai's well-being when he made it to California. Then I raised my children and helped put them through college, of course, with my Jimmy's help. Now as I write these last pages my daughter is about to have a baby and I hope to help her with this joy also.

So much has happened, though I don't say my life is complete because I have left so much half-finished, half-dreamed.